Classic Eateries

OF

CAJUN COUNTRY

Dixie Poché

AMERICAN PALATE

Published by American Palate
A Division of The History Press
Charleston, SC 29403
www.historypress.net

First published 2015

Manufactured in the United States

ISBN 978.1.62619.808.1

Library of Congress Control Number: 2015944405

Notice: The information in this book is true and complete to the best of our knowledge. It is offered without guarantee on the part of the author or The History Press. The author and The History Press disclaim all liability in connection with the use of this book.

It all started at the fais-do-do at the Rendezvous Club.
In appreciation to my parents, Jesse and Genevieve Huval.

CONTENTS

ACKNOWLEDGEMENTS

S howman P.T. Barnum once said, "There is much to be learned in a country store." Out of despair, Barnum's father opened a dry goods store in a New England hamlet, hoping to shape his son into a merchant. As a young clerk in a rural country store, Barnum fine-tuned his verbal skills and powers of trading in dealing with customers. His gift of gab served him well later in life as he perfected an entertaining personality. Valuable experiences behind the store counter, bargaining all the while, guided him through remarkable careers as a newspaper editor, museum director, lottery agent and, most famously, as a circus showman. Although he complained of many dull times during wet days at the shop, he paid close attention to the wit and wisdom of the people he met, honing his skills to become known as the "Prince of Humbugs," one of the founders of the Greatest Show on Earth, the Barnum & Bailey Circus.

My fun-loving experiences in a family country store while growing up piqued my interest to write about the hardworking men and women in old-time grocery stores, cafés and bakeries in the parishes of Acadiana, also called "Cajun Country." There are many of these mom and pop businesses, so popular for their nostalgic appeal as a welcome respite from the "big box" stores. What seemed to be a common thread was the dedication of the veterans behind the counter or in the kitchen, as well as the pure guts they displayed over the generations.

I am grateful for the assistance from all the librarians and visitors' centers along the way, directing me to research material and introducing me to a

ACKNOWLEDGEMENTS

foodie's paradise. Ah, how I was enticed by the delights of everything from plump boudin links to crispy French bread, crawfish served every which way, king cake and bread pudding to please my sweet tooth, lusty oyster poor boys (po-boys), rice and gravy and boiled crabs. As much as I love sampling the riches of Cajun cuisine, I admit that I did pass on the marinated beef tongue—I just couldn't do it! Thanks go out to all of the merchants for sharing their inspirational stories with me.

JAMBALAYA, CRAWFISH PIE AND FILÉ GUMBO

W hat is the world's fascination with the Cajun culture? Is it the mumbo-jumbo of spices in so many of the dishes that tantalize us? Lively music of accordion and fiddle? The hint of a French accent?

The *joie de vivre* (joy of living) through many festivals and hospitality play a large part in explaining why Louisiana has the five happiest cities in America. In 2014, a report from Harvard examined the happiness of cities, concluding that the five happiest cities in America are located in one state: the Pelican State of Louisiana. The cities were Lafayette, Houma, Shreveport-Bossier City, Baton Rouge and Alexandria. Lafayette took the crown as the "Happiest City in the U.S."

The Cajun people are descended from the Acadians who were exiled from Nova Scotia for political reasons in the mid-1700s. In refusing to take an oath of allegiance to the British, the mostly French-speaking Catholic Acadians faced tremendous hardships. Groups of families were separated through deportation. Thousands relocated to southern Louisiana, where they adapted to the bayous, swamps and prairies. While the Acadians learned to thrive in their new surroundings, they developed a cuisine, intermingling influences from other cultures within Louisiana: Spanish, German, Italian, Creole, Native American, African and French. Ever resourceful, the Acadians used their ancestral recipes while also introducing the fruits of their new terrain. They grew crops on fertile land along the bayous, hunted, fished and gathered herbs. The term "Cajun" is derived from "Acadian."

INTRODUCTION

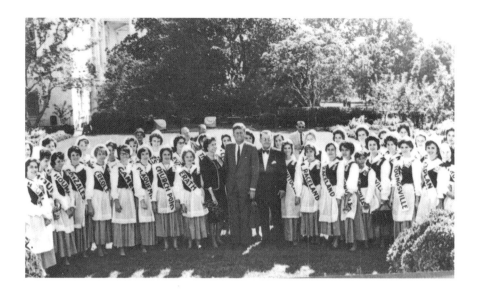

John F. Kennedy during his presidential campaign as he toured Louisiana. Shown with Louisiana Maids and Louisiana senator Dudley LeBlanc, who developed Hadacol. *Courtesy of Lafayette Parish clerk of court Louis J. Perret.*

National attention was brought to some of the more popular Louisiana dishes through Hank Williams's 1952 song "Jambalaya (on the Bayou)," which praises the dishes of "jambalaya, crawfish pie, and filé gumbo." When the lighthearted song hit the top of music charts, Americans became enamored of the Cajun culture and its tongue-tingling cuisine. As a son of the South, Hank Williams, born near Montgomery, Alabama, had a fond relationship with Louisiana because of the seemingly carefree lives of the Cajuns. He co-wrote the lyrics to the song while enjoying the one-pot wonder of jambalaya in New Orleans. Hank traveled throughout Louisiana, performing in many schoolhouses and honky-tonks. His Cajun fans were glued to the radio on Saturday nights to hear Hank perform from Shreveport, Louisiana's *Louisiana Hayride*. Hank also headlined a promotional tour of the Hadacol Caravan, journeying by train throughout Louisiana and much of America. The tour of the feel-good concoction of 12 percent alcohol, Hadacol, originated in Lafayette.

Understanding the Cajun culture begins with a peek into the kitchen, with images conjured up of a black-iron pot, big spoons for stirring, onions, bell peppers, celery, garlic, other seasonings and a rice cooker. Recalling the aroma and taste of the comfort food of gumbo on the stove transports us

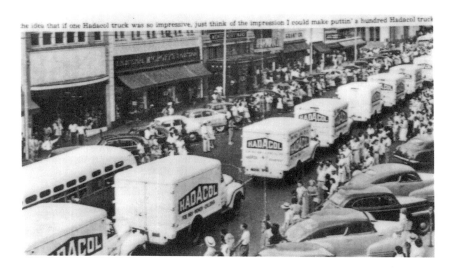

Train caravan promoting the tonic Hadacol in downtown Lafayette. Courtesy of Lafayette Parish clerk of court Louis J. Perret.

back to Maw-Maw's kitchen. Much of Cajun cuisine stems from a custom of slow cooking, often bolstered by cayenne pepper to uncover mouthwatering dishes for the community at large. The rituals of celebratory gatherings acted as a springboard to launch businesses in the food industry such as restaurants, grocery stores and bakeries. Beginning with preparing special dishes for the family in the home kitchen or at hunting camps, entrepreneurs were often inspired by these gatherings to try business startups.

- BOUCHERIES—Slaughtering of a pig, usually held in late fall or winter. It takes a full day to slaughter, prepare, cook and share every part of the pig (everything but the "squeal")—such as sausage, boudin, crackling and hogshead cheese. The day after a boucherie was often dedicated to making soap for the family by cooking down leftover pig lard and lye. Perfume and bits of old soap were tossed in for scent.

- COCHON DE LAIT—Literally means a "suckling pig." Local legends purport that members of Napoleon Bonaparte's army brought this tradition to Louisiana in the early 1800s. Pigs are splayed and hung, rubbed with seasoning inside and out and roasted all night over an open wood-burning fire. One locale that loves the "oink-oink" is in Avoyelles Parish at the St. Peter/St. Michael Catholic Church's

"Cochon de Lait," an annual fall community event in which twenty pigs are hung and roasted on a rotisserie. Each pig used in this forty-year-old event weighs up to 250 pounds. Across from St. Peter's Church is a shed along the bayou in Bordelonville built to accommodate the hanging of pigs. On Saturday, the pigs are rubbed with a seasoning paste and set up to roast all night under the careful supervision of volunteers. Butchers prepare the pigs by removing the heads. These heads are actually frozen and saved for a February "boucherie" in which hogshead cheese is made. At dawn on Sunday, the roasted pigs are carved; the skin is removed, and more than two thousand plate lunches are served and filled with tenderized pork meat, along with rice dressing made with pork liver. Avoyelles Parish boasts another piggy event in the nearby town of Mansura, which has hosted a Cochon de Lait Festival every Mother's Day weekend since 1961. It's a fun event with pig roasting, a grand festival parade, arts and crafts, a hog calling contest, a greasy pig contest, a carnival and French music.

- CRAWFISH BOILS—Crawfish boils are a big deal in Cajun Country as a popular social gathering. According to industry statistics, Louisiana accounts for 90 percent of the total U.S. production of crawfish through farms and natural waters such as the Atchafalaya Basin. Sacks of live crawfish are poured into big pots of water and boiled along with ears of corn, onions, sausage, mushrooms, potatoes and the right mix of seasoning. At a young age, children are introduced to peeling a crawfish using techniques of pinching, twisting and pulling to get the succulent crawfish tail off the shell in one piece. It's an informal, somewhat messy affair of layering dining tables with yesterday's newspaper and cascading a mountain of crawfish for the masses to devour. Dipping sauces are mixed, and rolls of paper towels are set out. Some etiquette points: (1) You've earned a badge of honor if crawfish guts are dripping on your shirt as a sure sign that you enjoyed eating with gusto. (2) It is not considered bad manners if you do not shake hands with your neighbors while you are in the midst of peeling crawfish. (3) Leftover crawfish? The tails can be recycled and used to cook crawfish étouffée. (4) Once you worship the earthy taste of the crawfish, it's easy to eat three pounds with reckless abandon at one sitting. (5) Slurping up or sucking the head of the crawfish is acceptable, even in front of company. As part of Cajun lore, it has been claimed that when the Acadians left

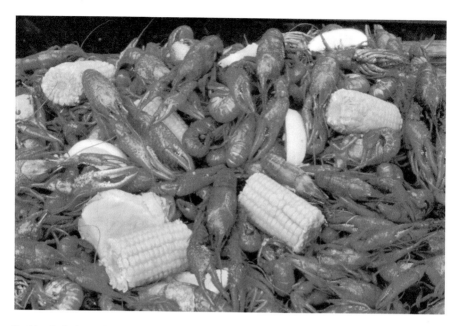

Red hot boiled crawfish. *Courtesy of the Louisiana Department of Culture, Recreation and Tourism.*

Canada, the lobster trailed behind. The trip was long and arduous. By the time the lobster reached Louisiana, it had lost so much weight that it had transformed into the smaller crustacean: the crawfish. And we love it just the same!

- *Fais-do-do*—Literally means to "go to sleep" in French, but it is known as a "Cajun dance." The ritual started as a community *bal de maison* (house dance) when families attended to enjoy dance and refreshments. Mothers brought their infants and small children, laying them to sleep in a separate room while the music and frivolity of the fais-do-do continued. From this tradition, some restaurants have evolved to play Cajun or zydeco music for families to mix dining and dancing.

- Festivals and Cook-offs—Louisiana boasts that it plays host to more than four hundred festivals each year, with many dedicated to the heritage of unique cuisine. In the historic downtown of Abbeville, chefs from across the globe prepare for the Giant Omelette Festival. More than five thousand eggs are cracked and mixed with the regional ingredients of Tabasco® pepper sauce and Louisiana

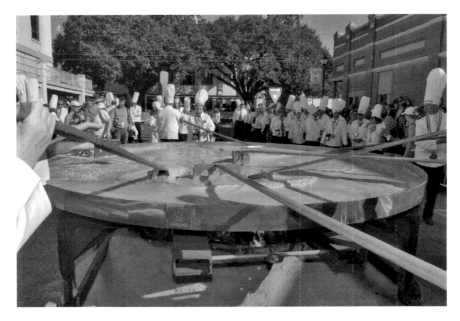

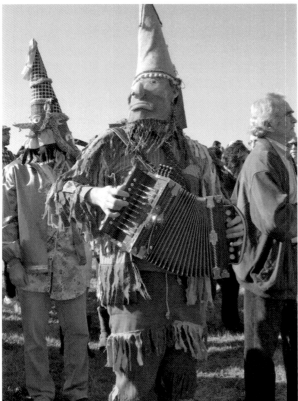

Above: Chefs preparing a giant omelette in Abbeville. *Courtesy of Giant Omelette Festival.*

Left: Masked musician playing the accordion during the Courir de Mardi Gras. *Photo by author.*

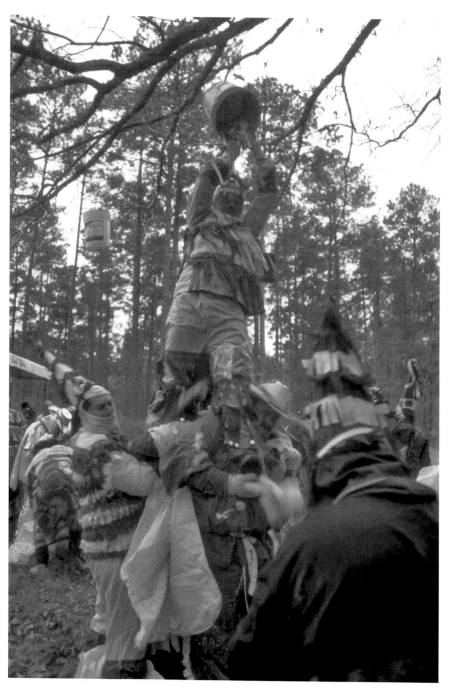

Catching chicken for gumbo during the Courir de Mardi Gras. *Courtesy of the Louisiana Department of Culture, Recreation and Tourism.*

crawfish tails. Along with milk and seasoning, everything is poured into a twelve-foot skillet. A supersized omelette is cooked for everyone to share, along with a slice of French bread. This is the only such celebration of its kind in the United States, tied to Abbeville's French roots. Abbeville's Omelette Celebration is one of seven members of a worldwide confrere (brotherhood) that cooks omelettes, including two in France and one each in Belgium, New Caledonia, Argentina and Canada. Another festival in little Grand Coteau dedicates itself to the "Sweet Dough Pie," a traditional "Cajun turnover with fruit filling" that has been a sweet treat in Louisiana for many years. For other events throughout Acadiana, you earn bragging rights when you win for "best dish" in a community cook-off, whether for wild rabbit, crackling, frog or venison.

- MARDI GRAS—Mardi Gras, or "Fat Tuesday," is the last day of frivolity before the solemn season of forty days of Lent begins for Roman Catholics. Many cities celebrate the high-spirited event in different ways. The rural setting of the "Courir de Mardi Gras" is very different from the glitz and glam of New Orleans's hullaballoo of balls, pageantry and parades. The Courir de Mardi Gras is a ceremonial run sporting bands of riders on horseback or in wagons. The energetic riders are dressed in homemade costumes with rainbow-colored, tattered-like fringes. Legend says this ritual dates back to medieval France. With a crazed merriment, the masked revelers set out on horseback, faithfully following their captain through the countryside. Stopping at various houses, they beg for ingredients to cook a gumbo. In exchange for a bag of onions or a live hen, the Mardi Gras group entertains by singing, playing music, telling jokes or performing childish antics. The hen is tossed in the air, and the Mardi Gras celebrants, all men, take chase to catch it. It's a wild time, with the day's festivities ending with a fais-do-do and a community gumbo. Business is booming for several eateries once Mardi Gras ends and Lent begins. Numerous fish fries and Lenten specials of seafood platters and boiled crawfish are plastered on menus for meatless Fridays.

REMINISCING

In America, the small-town grocery store was often considered the heart of the town, serving as a popular spot where men dropped in to have a beer after work—or teens a coke. Removing their hat when entering the store out of respect was customary. As the gathering place for neighbors, the store is where they shared stories of war and the Great Flood of 1927. Football scores of the local teams were announced. Election results were scrutinized. Tall tales of fishing from the banks of the Bayou Teche were revealed. Farmers brought in their sweet potatoes and corn ears to sell. Housewives came in to plan their menus and hand out recipes. Gardening tips were disclosed. The shopkeeper knew most of his customers and was familiar enough to inquire about their kids.

Along the countryside, there are many of these old-time grocery stores. Some are dilapidated with weathered signs and were boarded up many years ago. What still tugs at my heart are the memories of a similar country shop, closed for many years but still in good shape. My relatives owned Guidry's (pronounced "gid-ree") Grocery and Meat Market, located at the crossroads in Cecilia, Louisiana, a little community that still does not have or need a streetlight to control traffic. My uncle was called Pacquet ("pack-ket"). No one can recall how he earned that nickname, for he was born Mantor Guidry.

Within a mile from Guidry's, located at a strategic spot known as "Four Corners," there were at least six similar stores. Many families owned only one car, so walking on the side of the road (no sidewalks) or riding a bike to the store were other modes of transportation. A full parking lot in the

Mantor Guidry's country store in St. Martin Parish. *Courtesy of the Mantor Guidry family.*

morning in front of Guidry's meant that students had stopped in to buy last-minute pencils or glue on the way to school.

Guidry's market was a traditional, wood-framed white building, pieced together with additions as many stores were through the years. A house attached to the store made it convenient for the shopkeeper. During World War II, families experienced shortages and rationing. When the war ended in 1945, soldiers returned home to their families, welcoming a surge of prosperity. Housewives who had scrimped to prepare dinners during the war visited the grocery store with a new freedom and could now purchase sugar and butter for home baking. New homes were built with help from the GI Bill. Once the new homes were set up, they had to be filled with modern appliances such as the electric refrigerator. By 1950, more than 80 percent

of American families owned refrigerators, making food storage easier for keeping these "cold" items. More grocery stores, often set up by returning servicemen, were popping up. And Guidry's market was one of them.

Uncle Pacquet served in World War II in Sicily, where among other duties he was a butcher, learning a trade for his return to Louisiana. He became engaged to Ruth Huval, my aunt, during his three years overseas, sending her sixty-five dollars with the expectation that she select and purchase an engagement ring at Heymann's Department Store in Lafayette. She had joined the workforce during this time, earning some experience in the market business by working for an uncle in his grocery and meat market. She learned how to wait on customers and how to choose good meat cuts.

Much was also learned from early rituals of the Huval family boucheries, held in the colder months with cousins and aunts and uncles getting together. It was more than a social gathering—it was a necessity for providing and sharing food for big families. There were usually three pigs of two hundred pounds each that were shot and then butchered by the men. Everything from sausage to crackling to hogshead cheese was made. The women usually tended to the kitchen duties of seasoning, marinating meat and preparing the boudin.

To make boudin the old-fashioned way, the pig meat was quartered into small chunks and cooked with water in large cauldrons for a few hours. Once cooked down, the meat was ground and then mixed with cooked white rice. Green onions and parsley were important additions. The combination of seasoning, vegetables, rice and pork was stuffed into a thin casing made of pig intestines.

The boucherie was hosted on Saturdays, beginning early in the morning with lighting the fire to make ready to prepare a variety of pork favorites. All of the dishes had to be prepared in one day because there was no refrigeration in the early days. Everyone worked hard in slicing, cooking and cleaning up so the boucherie would be done by the time the *Louisiana Hayride* show was broadcast on the radio from Shreveport, Louisiana. This "Cradle of the Stars" featured a cavalcade of country singers like Hank Williams Sr., Little Jimmy Dickens and Kitty Wells.

It was from these family boucheries that Aunt Ruth learned how to prepare many of the Cajun specialties that were later served at Guidry's market. At the end of the war, Pacquet and Ruth were married, with plans to open a store, building from the ground up using Pacquet's savings during his war service. At that time, Cecilia had a big high school that accommodated a few nearby rural communities, as well as a movie theater, a hamburger stand, a post office, a canning plant, a syrup mill and churches.

Floor-to-ceiling shelves were stocked on Wednesdays with Mello Joy Coffee, Evangeline Maid Bread, Octagon washing powder, Ivory Liquid for washing dishes, canned goods and various sundries that you needed to run a household. There were bags of dried white beans and crates of onions, an ice cream cooler with popsicles and square boxes of ice milk. There were stockings (not panty hose) and Dippity-do hair gel for the ladies, moon pies for the kids and cigars for the gents. My aunt held on to the cigar boxes, which we used to store our small treasures. Dr. Tichenor's Antiseptic and baby aspirin were also available for what ailed you.

Customers came to buy fresh meat. Following the wartime shortages of meat, people were ready for juicy steaks and pork chops. Aunt Ruth was a gentle little lady, but her expertise at wielding a hatchet was legendary. She knew how to slice up thick, slightly marbled chops that were tasty when cooked down. She also had the knack of wringing the neck of a chicken, de-feathering it and prepping it to cook a chicken fricassee with no qualms. Links of fresh pork sausage were prepared using a cast-iron sausage maker. There was also a grinder to transform slightly pink ground meat into hamburger patties. Hours were spent preparing blood boudin, as that's what the customers asked for, most certainly in French.

To set up his market, Pacquet made his own butcher block by carving a tree stump. There was a system in running the store that worked. Meat was hung in the big walk-in cooler—pork and beef. Budweiser beer was also kept cold in there. Slabs of meat were cut, weighed on the white scale, wrapped in freezer paper and tied. My aunt and uncle used an old brass cash register with numerous levers, but that was just a formality. They added up customer tabs in their heads.

Pacquet took to dusty country roads with his truck bed stacked with ice coolers full of meat. A regular route of customers was mapped out as he stopped by to sell and deliver the meat cuts to make it easier for families. He was the salesman at large for a few years, while my aunt ruled the store, with three children running around.

In 1957, a tempest by the name of Hurricane Audrey visited the area, causing blustery havoc. Many communities, including Cecilia, were without electricity for two weeks. Coincidentally, Pacquet had slaughtered a few heifers before the hurricane and undoubtedly would have lost all of the meat. Out of generosity, the family wrapped the meat in small packages and loaded the truck to deliver to neighbors in need. The meat would have spoiled anyway, so why not provide food to the many customers who had supported him through the years?

The big draw, however, was the Sunday plate lunches, which were sold for $1.25 in the early '70s. A popular menu item included in the lunch was southern fried chicken seasoned with cayenne pepper and salt, dunked in an egg and milk mixture, dipped in flour and then fried in a big kettle filled with pig lard. The lunches also included pork roast that had marinated overnight before cooking, rice dressing, a vegetable such as sweet peas, a dinner roll, a few fried meatballs and candied sweet potatoes. Once the churchgoers exited from high mass and were ready to be fed, many stopped by Guidry's, so the lunches had to be ready on time. If a customer had to wait for his lunch, my aunt added a slice of her famous cake as *lagniappe*, French for "a little extra."

Guidry's market proved to be a training school in the art of customer service. The employees, though all family members, knew what to expect when on the job. The meatballs had to be rolled consistently to the same size and were lined up for inspection, ready to be dropped into the hot cooking oil. Everything had to be wiped down and served neatly and timely, so teamwork was important. Any disagreement or discussion of burnt dishes was kept in the kitchen and not aired in front of customers. Servings were generous so the customer felt that the plate lunches were of value as well as tasty. If a customer had a special request, every effort was made to accommodate him, and there was the usual departing greeting of, "Y'all come back." Besides earning a paycheck, employees were invited to enjoy a cold bottle of Dr. Pepper, certainly a treat for those who had only Kool-Aid at home. No one could leave until cleanup was completed. This included loading up a pickup truck and hauling off trash up the levee to a landfill, as these were the days before trash pickup in the country.

Blasting on the radio were Hank Williams's tunes in the late '40s and early '50s, country music in the '60s and rock in the '70s. There were jokes aplenty going around, accompanied by Uncle Pacquet's raspy laugh as he enjoyed a rapport with his customers. His favorite musician was Hank Williams, and my uncle envisioned that when he himself passed away, he hoped to go out on the same day as Hank Williams, which was January 1. And indeed he did—Uncle Pacquet died on January 1, 1973. Aunt Ruth, now in her nineties (both of her parents lived to their nineties), continued to hang the "Open" sign and welcome customers until the store closed its door for the last time in 1987.

ASCENSION PARISH

FIRST AND LAST CHANCE

812 Railroad Avenue
Donaldsonville, LA, 70346

As the parish seat of Ascension Parish, Donaldsonville has a wealth of riches for those who dabble in history. The picturesque town, founded in 1806, briefly served as the "Capital City of the Commonwealth of Louisiana." More than sixty buildings of the era between 1865 and 1933 are located in the historic district, along the west bank of the Mississippi River. An outstanding collection of Queen Anne Revival residences, a number of Italianate commercial buildings, shotgun houses, cottages, bungalows, government buildings and neighborhood stores tag the district as an architectural wonder. Playing an important role during the Civil War, Donaldsonville was the site of a star-shaped fort called Fort Butler, at the intersection of the Mississippi River and Bayou Lafourche. After the majority of the town was destroyed during the war, the railroad changed the face of the town, beginning regular service between Donaldsonville and New Orleans in 1871.

In keeping with the culture of a river town, the downtown area enjoyed the wheels of progress, serving as the site of many hotels, theaters, banks and general stores. The *Donaldsonville Chief* newspaper, published since 1871, is still located on historic Railroad Avenue.

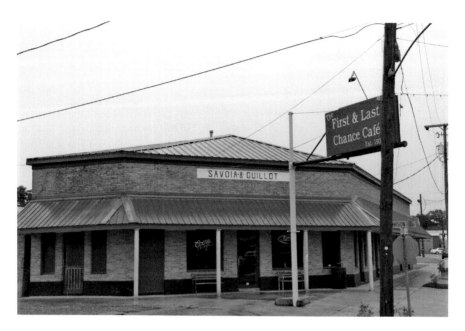

Railside café, with origins as a 1920s speakeasy in downtown Donaldsonville. *Photo by author.*

Donaldsonville played host to reunions of Confederate veterans, Warren G. Harding was U.S. president, the temperance movement of Prohibition was in full swing and Europe was on the brink of war when the First and Last Chance Café opened its doors in 1921. It was during Prohibition that a moonshine still blew up the original building when the First and Last Chance was a speakeasy. Rebuilt in the early 1930s, it has been a popular hangout since.

Situated in an ideal location next to the railroad depot, the café was so named because it was the first chance for departure and also the last chance for passengers to enjoy a drink or a bite to eat before reboarding.

Julie and Billy Guillot have owned the boxy bricked café for more than thirty years, taking over from Billy's grandfather. According to Julie, at one time Donaldsonville was the only rail stop between Baton Rouge and New Orleans. During the world wars (both of them), a lot of servicemen stopped by. It is rumored that members of the Long political dynasty were frequent guests at the Chance Café for meetings.

Julie relayed a touching story concerning an artifact found in the Chance Café. There was an old "Voories Cracker Box" containing a treasury of letters from local soldiers during World War II. During their time stationed overseas, they wrote letters to family members. The "foxhole" stories ended

up at First Chance Café. Julie undertook a mission of deciphering and distributing these heartfelt letters to the family members of soldiers.

With Prohibition days over, you can nurse a cold brew or whiskey sour as you enjoy a juicy hamburger, seafood or steak in this rustic setting along the tracks. Brick walls, ceiling fans from tall ceilings and plenty of seats provide an ideal atmosphere for making friends as in the old days. Fellow diners snag a seat at the bar, which originates from the Jax Brewery of New Orleans. The First and Last Chance Café is so authentic that it was selected for filming of the HBO miniseries *Bonnie and Clyde*.

The Cabin Restaurant

5405 Highway 44
Gonzales, LA, 70737

The Great Mississippi River Road of Louisiana runs through Ascension Parish. This seventy-mile corridor is located between Baton Rouge and New Orleans, where once both sides of the river were lined by monumental plantation homes, most built by wealthy sugar planters in the Greek Revival style. There are still a few antebellum homes that remain surrounded by moss-draped oak trees.

So magnificent was the scenery and majesty of the plantations that when Mark Twain journeyed to the area down the river in the early 1800s, he called it "a most home-like and happy-looking region."

There's history in every corner of the Cabin Restaurant, a pillar of Dixie cookery. The Cabin property, near the historic River Road, belongs to the Al Robert family; his father ran a service station. The old pumps out front give the place a country feeling. It's a sprawling complex with old structures that have been moved from nearby towns and restored.

The Cabin began as one of the ten original slave dwellings of the Monroe Plantation estimated at 180 years old. Adjoining the Cabin is the Burnside General Store, which also includes a post office, as many stores served dual purposes for communities. The shelves are filled with memories of the old days, providing a special atmosphere for private dining. There are crocks from yesteryear, old milk containers, an old coke machine and antique farm implements. The first African American Catholic Schoolhouse, built in 1865 by the sisters of the Sacred Heart, was moved from the nearby town of Convent and is now used for private parties.

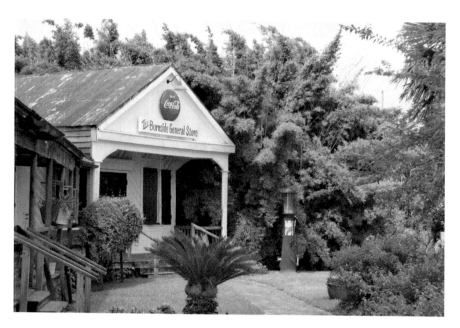

Burnside General Store at the Cabin Restaurant, a pillar of Dixie cookery. *Photo by author.*

Original slave quarters, more than 180 years old, at the Cabin Restaurant. *Photo by author.*

As you step through the entranceway to another time, you'll spot newspapers from the 1920s lining the wall. The *New Orleans Times Picayune* newspapers were not posted for decoration but rather served as a way of insulation through the old method of mixing flour, water and paper to paste to the wall. The main dining room was designed to resemble a garconnier (visiting bachelors' quarters on a River Road Plantation) and opens via French doors to a brick courtyard surrounded by two more slave cabins, both from the Helvetia Plantation.

The restrooms are one of the most unique features of the Cabin. Stall doors constructed from a cypress water cistern were once used to store fresh rainwater. Partitions in the restrooms are from the Old Crow Distillery in New Orleans.

The Cabin property was used during the filming of the movie *Twelve Years a Slave*, a 2013 historical drama based on the slave narrative memoir by Solomon Northup. The film sets included the Cabin's authentic slave cabins, general store and restaurant (for the tavern scene).

Among the Cabin's specialties are southern cornbread, buttermilk pie, chicken and andouille gumbo and jambalaya, long savored by locals. Jambalaya is a rice dish similar to the Spanish paella. It's one-pot cooking with flavors from a variety of meat, seafood and vegetables. The town of Gonzales has hosted the Jambalaya Festival since 1967.

BELLINA'S GROCERY

204 St. Patrick
Donaldsonville, LA, 70346

What makes ordinary tasks extraordinary? Every morning, Michel Bellina opens up shop for his customers, sweeps up the entrance and routinely prepares several hams. It begins with steam blossoming in the air as the ham is boiled in the same way it has been done for many years—in his grandfather's U.S. Navy surplus cooking pot. Slicing takes place at the counter. Keeping the ham moist and juicy is a Bellina's Grocery trademark.

Many Italians looked for opportunity in America, and Michel's grandfather was one of them, immigrating to Louisiana with empty pockets and settling in rural Ascension Parish as a truck farmer. Michel's father, Michel Sr. (called "Mike"), was raised in the country in a family of thirteen, working the land to grow a home garden, hopefully as a

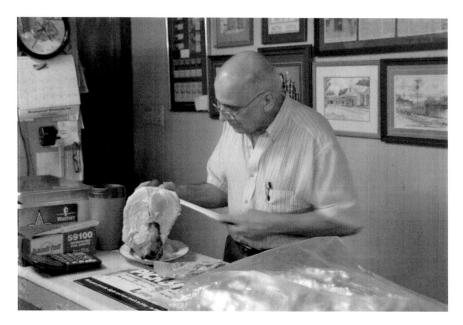

Michel Bellina carving his trademark ham. *Photo by author.*

livelihood. With fertile soil and proper tilling, the garden grew into an eleven-acre farm, allowing the family to sell produce.

Bellina's Grocery is not too far removed from the day when it opened in 1944 on St. Patrick Street. There were once thirty corner grocery stores; today, Bellina's may be the only remaining "old-time" shop in the parish.

You don't have to rush through. Take your time looking around at the shelves filled with bagged white and red beans and wood slat cartons overflowing with homegrown tomatoes, okra and potatoes. Specialty items of black olives and salami imported from Italy fill the cooler. A favorite cheese from the "old country" is Pecorino Romano cheese, a hard, salty Italian cheese made of sheep's milk that Michel cuts into wedges from large blocks.

In the early days, the Bellinas prepared cold-cut sandwiches for the neighborhood schoolchildren who dropped by for a quick lunch at a quarter a sandwich. The humble green legume from Italy, the fava bean, was available in cans and used to prepare a green gravy for spaghetti or used to cook down to prepare as a soup. Fava beans were traditionally eaten in Italy in the fields as a nutritional snack to sustain men and women while working. These beans are considered lucky, much as four-leaf clovers are.

Customers call in for the ham bones because they add flavor when cooking soup or red beans and rice. Red beans and rice was traditionally cooked on

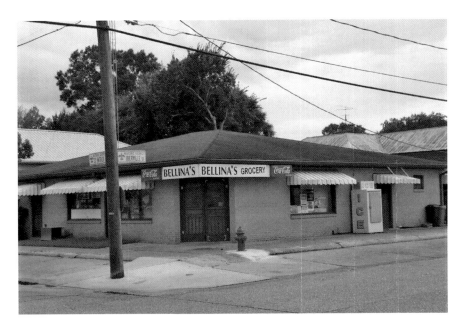

Bellina's Grocery, one of the few old-time country stores in Ascension Parish. *Photo by author.*

Mondays because that was washday, and it was an easy dish to cook on the stove for hours, with just an occasional stirring.

"The only good thing about the good old days was that we were young," Michel joked. He has worked here all of his life while growing up in the house that adjoins the grocery store. One of his first jobs was taking orders over the phone as a teenager. "I was scared to death I would mess up," he said. Special orders were delivered by bicycle. Even if the customer needed only one loaf of bread, Michel pedaled down the street with it in his basket.

Much ado was made when actor Clark Gable worked in the area, portraying a sugar plantation baron in the 1957 movie *Band of Angels*. The nearby plantation called Ashland-Belle on the River Road was used as one of the settings. Bellina's Grocery has always closed on Sundays, a traditional day for visiting family. A family friend pleaded that Mr. Clark Gable was hungry and suggested that a sampling of the Bellina's special ham would be delightful. There was no red carpet laid out, but the doors were opened for Gable to get slices of ham in sandwiches, nonchalantly enjoyed in his car.

For many years, the Bellinas have supported the local Catholic church's observation of St. Joseph Altar, which takes place around March 19. This Italian tradition includes preparation of an elaborate spread of delights, including fruits, breads that may be shaped like fish or lamb, "Bible" cakes,

Italian fig cookies and other sweets and nuts, among candles, flowers and statues. All of this, including a meatless spaghetti where eggs are boiled and used in place of meat, is shared with the public and given to the needy. This ritual began in Sicily during the Middle Ages to thank St. Joseph, their patron saint, for favors granted.

Michel is one of four brothers—a doctor and two pharmacists. Michel attended Nicholls State University in Thibodaux, Louisiana, but was nominated to take over the vintage shop. His father had to deal with changes, like discontinuing delivery of groceries and learning to use an electric cash register. In 1976, he retired, and Michel took over, running the store in the same fashion, closing on Sundays and Wednesday afternoons. "We offer something that big stores just don't have," Michel added. Tell them what you want to cook for supper, and they'll steer you right.

AVOYELLES PARISH

T-Jim's Grocery & Market

928 Dr. H.J. Kaufman
Cottonport, LA, 71327

There is royalty of a different sort in the bayou town of Cottonport, as "T-Jim" James Moreau has been informally crowned "Boudin King." While a tobacco salesman, T-Jim learned of the retirement of the owner of Vance's Bar and Grocery, effective December 1964. As a twenty-five-year-old newlywed, T-Jim saw an opportunity to make a good living for his wife and, one day, a family, so he bought out the country store. It was a grocery store, bar and meat market, and at one time, it had a room in the back. He eventually closed the bar, converting the business to T-Jim's Grocery & Market. When the store burned in 1997, the building was nearly a century old.

The downtown establishment was rebuilt, and eventually the "Son of Boudin King," Jacques Moreau, took over from T-Jim. Like many children of mom and pop stores, Jacques grew up in the family business. As soon as he was tall enough to see over the counter, he earned his first paycheck. It was at the chopping block that he mastered the art of butchery from his father. Jacques has worked in the store for most of his life, except for a move to Baton Rouge, where he worked in a chemical plant for ten years.

"To be a great butcher, you have to use fresh hogs," Jacques said with a ready smile. He caters to his customers, selling an average of one thousand

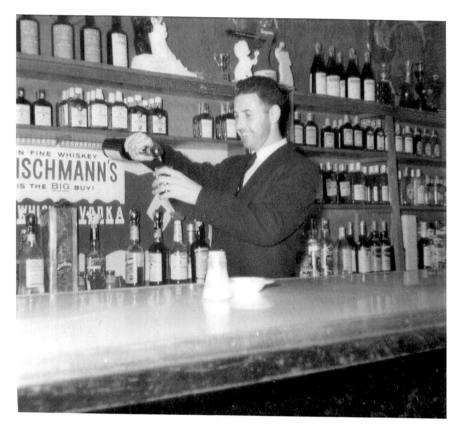

T-Jim Moreau in the early days at his store, bar and meat market in Cottonport. *Courtesy of T-Jim's Grocery & Market.*

pounds of fresh sausage a week. And some like it smoked—Jacques uses a forty-year-old, well-seasoned smokehouse for those who prefer smoked meats. "We make our own sausage and smoke it ourselves using real wood," Jacques added.

The smokehouse has lasted quite a while. A few years ago, the wind of a hurricane blew through town and picked up the smokehouse, moving it clear across the street. The Moreaus determined that a little old hurricane would not shut them down, so they relocated the smokehouse to its original spot, behind T-Jim's Grocery.

Customers love the hogshead cheese, calling it Cajun pork paté. The name hogshead cheese is derived from an old custom of actually using the heads of hogs to make mixtures gel, although T-Jim does not use this in his mix. Hogshead cheese can be served as an hors d'oeuvre with crackers and

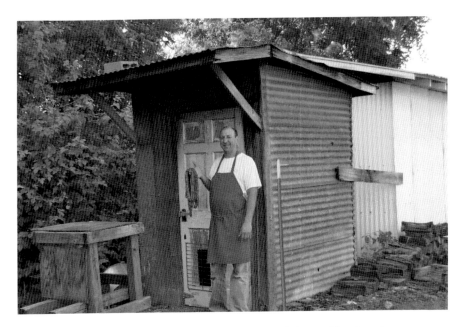

Jacques Moreau preparing boudin and sausage at his smokehouse. *Photo by author.*

French bread or dipped in mustard. Jacques takes fresh hocks from the hog, as well as pigs' feet. "This is what makes it 'gel' naturally. We don't add any gelatin," Jacques explained.

For three hours, the mixture is boiled until the batch is cooked. The meat, with bones still in, is placed in a pan while it cools off. Deboning is done, and seasoning is added. To help it all gel, the deboned meat and seasoning are ground to a smooth texture with broth added from the cooked meat. Peppers and green onions are stirred in until there is a consistency of slush. Molds can be used to make a nice presentation at parties for serving the hogshead cheese. The locals like the LSU (Louisiana State University) lettering molds and the "fleur de lis" of the New Orleans Saints football teams. It takes four hours to harden in a cooler before serving.

T-Jim's turns out delicacies of just about every part of the pig, such as gogs (stuffed pork stomach, also known as chaudin) and blanc (white) boudin. Blood (rouge) boudin is also prepared in-house, although it's not something you will find at many markets. For processing, blood is obtained from an inspected hog at the slaughterhouse. T-Jim's Grocery is so good that Jacques won first place in the "unlinked" category at a recent boudin cook-off in Lafayette. Also popular are pork patties called *pain d'toilettes* in French. These are seasoned fresh bulk sausage patties wrapped in fresh pork

webbings instead of casings. To prepare this specialty, you cook it as you do fresh sausage. It is delicious in a gravy served over rice or with grits for a hearty brunch.

T-Jim's is also famous for starting up a tradition in Cottonport—"Pocking of Easter Eggs." Pocking (also called knocking) is a fun event in many Cajun communities, and it's not just for kids with Easter baskets. In 1966, James Moreau held the first pocking contest in Cottonport, where folks of all ages knocked their dyed Easter eggs. The fierce competition, though a bit comical, is accomplished by each opponent holding his or her egg tip to tip, in the struggle of which egg will be the first to crack. The eggs that are cracked after battle are usually cut up and used to make potato salad for Easter dinner.

Families take these skirmishes seriously, however, gathering eggs in search of the strongest to win in combat. Some prefer speckled guinea eggs, while some folks feed their poultry a special diet, like bits of oyster shell with calcium sand. T-Jim's wife, Kinta, dyed up to thirty dozen eggs for the first year. She spent hours slow-boiling her eggs, carefully selected from the chicken coop. To protect them from cracking, she placed a towel at the bottom of the pot to cushion the eggs, which are pointed face down. Natural dyes such as berries (blue), tea (brown) or beets (red) or food coloring for bright hues were used.

For the first egg pocking competition at T-Jim's, contestants, mostly men, were allowed to register three eggs with no entry fee. The winner of the "last egg standing" without cracking from the opponent's pocking received a case of beer or a fifth of whiskey. The contest has grown into a community-wide festival at Easter time and is known as Pockin' on the Bayou.

ADAM PONTHIEU GROCERY STORE, BIG BEND POST OFFICE MUSEUM AND SARTO OLD IRON BRIDGE

8554 LA 451
Moreauville, LA, 71355

In case you needed a squirrel trap, you knew where to find it. The Adam Ponthieu Grocery Store in Big Bend, Louisiana, had a little bit of everything.

Thomas Hall Carruth established a general country store at this site in 1900, with his son-in-law, Byron F. Lemoine Sr., eventually taking over the

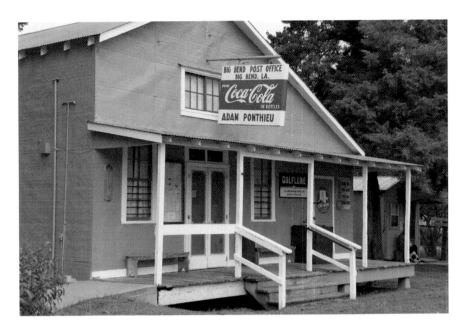

Adam Ponthieu Grocery Store and Museum in Avoyelles Parish, depicting a country store from the era between 1900 and 1950. *Photo by author.*

operation and also becoming Big Bend's postmaster (1920–47). Although the store was destroyed during the Great Flood of 1927, Mr. Lemoine constructed the present building to accommodate a store and post office to serve the needs of the area. Adam Ponthieu Sr. began working at the store and post office in 1930, purchasing it years later (1946). Following the relocation of the building a few hundred yards to what is now the present location, Mr. Ponthieu was appointed postmaster in 1947. He continued in that capacity until the post office closed in 1994. The store, post office and property were donated to the Louisiana Commission de Avoyelles for use as a museum to portray a typical country store from 1900 to 1950. The museum draws attention even on election days, as it is still used as a voting precinct.

The first sight upon entering the museum is the potbellied stove, where folks gathered to warm their hands and feet while sharing their news. There's a 1927 Maytag gasoline-powered washing machine, original scale for weighing produce, lady's curling iron, ballot box, butter churn and corn shucker. A Louisiana crosscut saw called a *passé partout* ("passing or cutting") is displayed, so named because it was commonly used to cut through trees. You got your beans, drip coffeepot, tools, hairbrushes, fabric and other

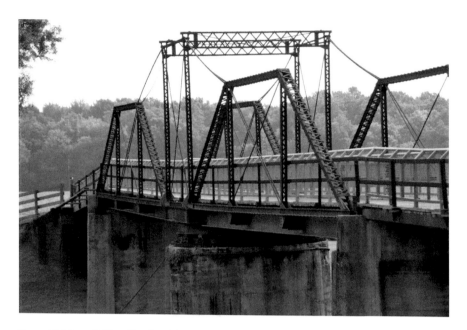

Sarto Old Iron Bridge, first Louisiana bridge to be placed on the National Register of Historic Places, located in Avoyelles Parish. *Photo by author.*

sewing notions here. When homemakers picked figs, they got their canning jars here, as well as sugar in preparation for cooking fig preserves. You were lucky if you had good hens at home because you could carry your basket of fresh eggs in and walk out with a bag of sugar for trade. The grocery store section stocked mostly smaller items because customers ordered larger items through the Sears catalogue.

Serving as a time capsule to bygone days, the museum houses local family histories, keepsakes and photos of the area. Maps show how the Great Flood of 1927 altered the dynamics of the surrounding communities, destroying homes and crops and changing lives dramatically. At one time, Big Bend was the site of a cotton gin, a syrup mill, a blacksmith shop and a moss gin. Rather than using cotton in upholstery, car seats and home furniture were stuffed with dried and cleaned moss.

Across from the store is the Bayou de Glaises, where steamboats traveled through the meandering bayou that forms an oxbow, or "big bend." Dry goods, cotton and corn were exported to sell in New Orleans. The picturesque scenery includes the Sarto Old Iron Bridge, the first Louisiana bridge to be placed on the National Register of Historic Places. A rare survivor of this type of bridge, the steel swing truss bridge,

completed in 1916 for vehicular and boat traffic, could be turned with a big steering wheel.

The museum hosts a summer arts and crafts program for children with demonstrations of "old fashioned" fun like making homemade ice cream, cornhusk dolls and soap.

EVANGELINE PARISH

TEET'S FOOD STORE

2144 West Main Street
Ville Platte, LA, 70586

After World War II, Lawrence "Teet" Deville was a hardworking sharecropper. He also ventured out on country roads to deliver loaves of fresh-baked bread to grocery stores. His hometown of Ville Platte, French for "flat town," is so named because it was the first settlement on level land that stagecoach passengers reached when traveling south from the rolling hills of north Louisiana. His nickname, "Teet," was a derivative of "Petit" because he was a small man in stature, though not in determination. After many years of driving through the Louisiana parishes, he received a sharp warning that it was time to stay off the road. Once while driving the bread truck, he stomped on the brakes. The truck came to a screeching halt, but that did not stop one of the tires from popping off the rim and rolling on down the street. Perhaps it was time for Teet to earn a paycheck in a different way. He looked to his past experiences during World War II, when he was stationed as a cook in Alaska.

In 1955, Teet and his wife, Ruby, opened a general merchandise/grocery store/meat market on the main drag in town. In the '50s, Ville Plate was known on the music scene for its "swamp pop" music, Louisiana's style of rock-and-roll. Teet's was next door to the lively Evangeline Club, a honky-

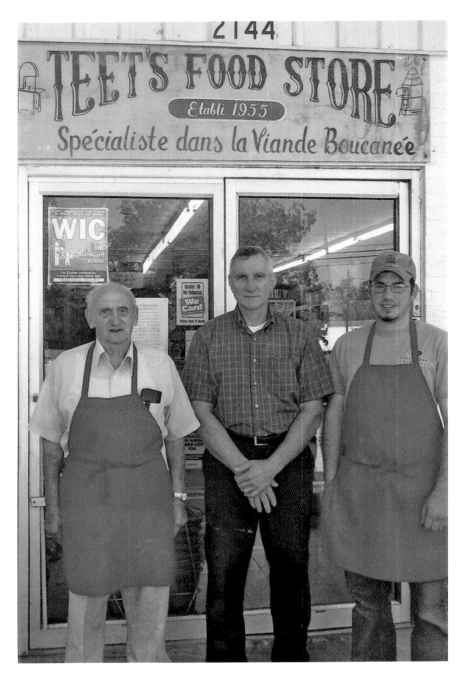

Three generations at Teet's Food Store in Ville Platte, which opened its doors in 1955. *From left to right*: Lawrence, Chris and Luke Deville. *Courtesy of Teet's Food Store.*

tonk frequented by soldiers from nearby Fort Polk, especially busy during the years of the Vietnam War. There was a strict dress code; soldiers were not allowed to enter the club in military uniform, so they had to find a change of clothes. The solution was easy: they walked next door to Teet's with cash in hand, buying jeans and a shirt to change into, as well as a handy snack: a link of boudin.

Twenty years later, the Devilles built a modern store across the street while expanding the fresh meat department. Although there was once a grocery store on each corner, Teet's scent of swine on the racks from the rustic smokehouse draws customers in as a worthy stop-off.

The Deville family is still at the helm. Teet's son, Chris Deville, a graduate of Louisiana State University in the medical field, and his son, Luke, a graduate of the University of Louisiana–Lafayette, open the doors every day to manage the store. Rightfully, they brag about their ponce. So well-known is this specialty that Teet's designed a T-shirt that you won't find anywhere else, proclaiming, "Peace, Love, and Ponce."

According to Teet's grandson, Luke Deville, ponce is a pig's stomach that has been stuffed with pork sausage meat, followed by a thorough smoking for several hours. The smoked ponce can be cooked either on the stove or in the oven in the same way in which a roast is prepared. A popular variety is the "jalapeño cheese ponce." The secret to preparing ponce is to slow-cook the hunk of pork. When slow cooked, the ponce becomes tender, just right for slicing and serving on rice in a sea of brown gravy. You can also reheat leftover ponce and pile it up between two slices of bread to make a Cajun sandwich.

Teet's has developed its own seasoning mix, using the Cajun favorite of cayenne pepper as the key ingredient. The long list of smoked meats available includes beef jerky, fourteen different sausages, turkey tasso, pigtails and oxtails. Seasoned meats are also available for the grill. Teet's backyard smokehouse has a simple design after many years of trial runs. "All you have to do is hang the meat on the hooks and check the woodpile to keep the fire smoldering. You'll know when it's ready by the aroma," Luke said.

Cooking smoked ponce is a tradition in Evangeline Parish, the host of an annual Smoked Meats Festival, or Le Festival de la Viande Boucanee. Credit the Choctaw Indians, who taught French soldiers stationed in Evangeline Parish the art of smoking meat. It's a way for family and friends to get together—Luke Deville and his cooking team of Justin Lafleur, Jules Jeanmard and Ryan Fontenot have won many cooking competitions for their distinctive way of cooking ponce, sausage, tasso and andouille. Not to be

outdone, Uncle Wayne Deville has taken home trophies as well. They have also competed in the Rabbit Festival in Jefferson Davis Parish, preparing smoked rabbit and rabbit sauce piquante. Teet's sells both imported and domestic rabbit to customers.

Workers at Teet's, including many family members, regularly enjoyed Grandpa Teet's lunches. While still in his eighties, Teet would pop in at the store to cook rice and gravy for the lucky crew. While checking the specials of the day, Teet decided what to cook, although his chicken fricassee was one of the best. Although he used no measuring cup, with his slow-cooking technique, the right proportion of seasoning and vegetables and his favorite black pot, the dish came out full of flavor from years of experience. While telling jokes in French, he stirred the pot while laughing with his friends. (Note: Grandpa Teet died in February 2015 at age eighty-eight. His family said he "never missed a beat in enjoying life.")

IBERIA PARISH

Theriot's Deli & Market

330 Julia Street
New Iberia, LA, 70560

Theriot's is a legendary lunchroom that Dave Robicheaux frequents. He's the ornery detective from the 2009 movie *Into the Electric Mist*, based on the best-selling thriller by New Iberia native son James Lee Burke.

Actor Tommy Lee Jones, who portrayed Dave Robicheaux, journeyed through the historic New Iberia downtown set among towering live oak trees along the banks of the lazy Bayou Teche. While sampling local dishes, movie scouts enjoyed the old-fashioned feeling of Theriot's Deli & Market. The big window front would be a charming setting for a scene in the movie, they thought. A centerpiece of Theriot's is the French sign proudly proclaiming that the store carries "fresh meat and chicken, boudin, and cold beer," constructed as a prop for the movie, as recommended by the movie director (who happened to be French).

Crawfish étouffée was the local dish the crew chose for the movie scene in which the main characters have lunch. In preparation, David Theriot ordered the freshest of crawfish tails, chopped up onions and bell peppers, assembled his favorite seasonings and took out his worn cooking pot. On the morning of the movie, however, the movie crew set up, checked the lighting, moved furniture around and unexpectedly changed their mind. A

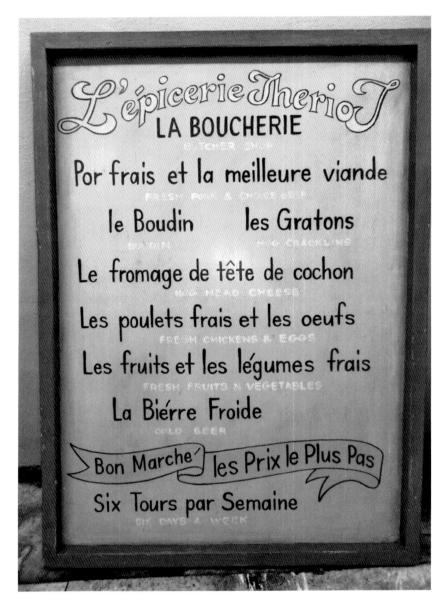

French sign at Theriot's Deli & Market in New Iberia. *Photo by author.*

decision was made that David should switch to cooking fish court-bouillon instead. He walked to the fish market to start all over. He wasn't nervous, though; he's an old hand at Cajun cooking techniques, learned from his father, Paul.

Paul Theriot worked for A&P Grocery Stores throughout Louisiana until 1941. From his years in this up-and-coming grocery supermarket, he learned about ordering stock, setting up produce, running the register and managing people. He decided to open his own store by purchasing the Rosemond Leblanc Store on Julia Street in New Iberia for $750. That was just for the business, not the building.

In his neighborhood grocery store, everything you needed was stocked, just a few steps from home. Business was going well. Even though ration coupons were used for sugar and coffee, customers were loyal, and Theriot's always carried fresh meat. When World War II hit, Paul was drafted into the army. He served in the famous Thirtieth Infantry's "Old Hickory Division," so named for President Andrew Jackson. After the United States officially entered World War II, the division arrived in England, enduring training until landing at Omaha Beach, Normandy, France, in 1945. This was five days after the D-Day landings had begun. Serving as a mess sergeant in the medical battalion, Paul fought in France, Belgium, Holland and Germany.

Back at the store, Paul's sister, Irene, and their father, Ferdinand, formerly a carpenter and blacksmith, filled in. When the war ended, Paul returned to the helm at the grocery store. Recognizing that times were tough and that customers may be a few dollars short now and then, Paul offered credit to help out local families. In the 1940s, he ceremoniously kept a "tab box" to keep track of who bought their groceries on credit. Even many years later, when credit was no longer offered, Paul would periodically take out his box and flip through the tickets to check which customers still owed him. David keeps the "tab box" for sentimental reasons.

Early on, Theriot's groceries were delivered in the neighborhood by bicycle. "You could get more groceries for twenty dollars back then," David Theriot commented. "It used to mean two trips, and you had to be careful not to crack the eggs," he added. Deliveries were made before and after school and on Saturdays from 7:30 a.m. to noon and again from 2:00 p.m. to 6:00 p.m. In the 1960s, Theriot's dug out old family recipes and began making the Cajun staples of boudin and crackling.

In 1975, about the time when Paul's son, David, took over, the grocery shelves were removed, and tables and chairs were set up to accommodate a noonday crowd. The business became all about food, with daily plate lunches, Sunday barbecues and catering. Specialties include turkey rolls, hogshead cheese and sausage. Shrimp and crab stew and other seafood dishes are served on Wednesdays and Fridays. Every day you can order grilled or fried shrimp poor boys and hamburgers. The hiss of the deep fryers draws steady

customers from the courthouse around the corner for Theriot's fried fish, and the pork chops also lure them in.

Gumbo has appropriately been declared Louisiana's official state cuisine for its popularity. So it is fitting that the team of David and his son, Mike, compete in New Iberia's fall Gumbo Cook-off. Using a big, worn gumbo pot, the Theriots cook seafood gumbo full of shrimp and crab.

LeJeune's Bakery

1510 West Main Street
Jeanerette, LA, 70544

In Jeanerette, the "sweetest place in Louisiana," a red light flashing signals that French bread, golden and crunchy, is just out of the oven at LeJeune's Bakery, a gem of a place more than 130 years old.

Originally called Old Reliable Bakery, it was established in 1884 in the same building as today. Although once a wood-framed structure, the bakery was remodeled in 1913, with fancy brickwork added along with a glassed-in storefront. The building was listed on the National Register of Historic Places in 2003, the first bakery in Louisiana to be placed on the register.

It's been in the LeJeune family since the beginning, and sixth-generation family member Matt LeJeune proudly manages the bakery. The first LeJeune, Oscar, was a baker, and with a Frenchman named François, they developed recipes that are still used today. They originally had a full house of baked goods—cookies, pastries and cakes.

Walter LeJeune Sr. and O.A. LeJeune, first cousins to the original owner, bought the bakery in 1900. They shared their baked goods throughout the region by utilizing one of the first horseless carriages in town for deliveries.

During World War II, some staples were hard to get. "If the bakery ran out of fruit, they would pick up fruit from the trees to make the jams and preserves for the pies. If they ran out of lard, a pig was killed. The bakery always found a way to please its customers," said Loretta LeJeune, Matt's mother, who still works in the bakery office. Since baking was once done around the clock, families playing ball in the nearby park stopped by to pick up hot French bread at all hours. "The aroma of baking traveled," Loretta added.

When local chain stores moved into Jeanerette with their own renditions of baked goods, the smaller bakery business had to change. "We decided

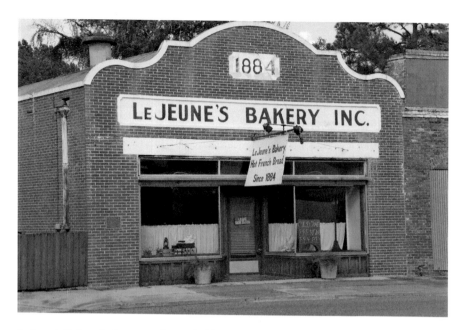

LeJeune's Bakery in Jeanerette began baking bread in 1884. *Photo by author.*

to specialize in French bread. It takes talent to shape the bread. It's not an art that everyone can accomplish, and we continue to make it by hand," Loretta said.

The oven is lit way before the sun rises every weekday as the process of making bread begins. Puffs of flour, yeast and all of the other ingredients are added to the big mixer with a dough hook. The dough is flopped onto the worktable, punched by hand and rolled with a giant rolling pin. The mounds of dough are set in proofing boxes for rising. "Each loaf weighs a pound. The shape may vary a little, but the weight is consistent," Loretta explained. "And it's the steam that gives the French bread its crispness."

Customers love spreading a spoonful of fig preserves on a slice of crispy French bread. Or they like to dip it in gumbo or spaghetti sauce or maybe smear it with a pat of butter.

Soft and spicy ginger cakes are perfect for biting into. LeJeune's old-time snack cakes are scallop-shaped, the way Oscar made them, using specially made "cookie" cutters. A batch of ginger cake batter (one of the ingredients is Steen's Pure Cane Syrup) weighs 225 pounds.

"The baking process has not changed in 130 years," Loretta commented. The French bread is still baked on sheets of slate. To place the bread dough in the oven and remove the baked loaves, a peel is an essential tool. Similar to

a small paddle, a baker's peel is a flat board with a long wooden handle, used to pick up a few loaves at a time. As the patron saint of bakers, St. Honoré (also called Honoratus) became bishop of Amiens in northern France during the sixth century. Legend says that when he was named bishop, a baker's peel was said to have put down roots and transformed into a mulberry tree, producing flowers and fruit.

The second brick oven at LeJeune's was built in 1907. With modernization, a newer oven from 1943 is used daily to produce three hundred loaves of bread at a time within a baking time of twenty minutes. By 7:00 a.m., ask anyone around—the first loaves are ready. Other items, many delivered to grocery stores and restaurants, include garlic bread, po-boy bread, dinner rolls and hot dog buns.

Jeanerette is still the kind of small town where kids ride on bicycles along the sidewalk waiting for the red light to turn. It's a sure sign that there's "Hot French Bread!"

JEFFERSON CAFÉ

5505 Rip Van Winkle Road
New Iberia, LA, 70560

A whimsical twenty-year slumber, peacocks roaming freely through tropical gardens, gold coins buried by pirate Jean Lafitte, a disappearance of sixty-four acres within a few hours, stories of friendly spirits on the grounds and a visit by President Grover Cleveland—all are part of the colorful history of Jefferson Island.

Once known as Orange Island for its impressive orchard of orange trees, Jefferson Island was acquired in 1869 by third-generation stage actor Joseph Jefferson, a colorful character himself. Originally from Philadelphia, Pennsylvania, Jefferson was touring in New Orleans. The appeal of the island as a hunting retreat enticed Jefferson to buy the 3,600-acre distressed property from the Dupuy family for $28,000. Although Jefferson traveled throughout the world with his acting troupe, he was especially famous for 4,500 performances as "Rip Van Winkle," based on the Washington Irving tale of a young man who went squirrel hunting in the woods to hide from his wife. As the story goes, Rip Van Winkle enjoyed a few drafts of beer and fell into a deep sleep for twenty years. Jefferson was also a talented naturalist,

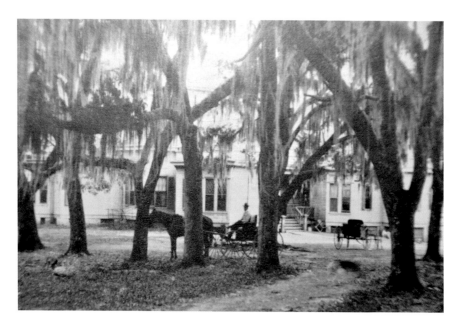

The Joseph Jefferson Mansion, of Moorish design, in the early days. *Courtesy of Mike Richard.*

writer and artist of landscape paintings. Although he already owned homes in Florida and Massachusetts, Jefferson delighted in the waterfowl hunting refuge he found at Jefferson Island.

He built a stately mansion of Moorish design at Jefferson Island in 1870 overlooking Lake Peigneur. The ten-thousand-square-foot manor, constructed of virgin cypress cut from trees on the island, has a cellar, a rarity in Louisiana. Bedrooms, a hunting room, an inviting foyer with one-hundred-year-old silken murals, a library, a rustic kitchen and a formal parlor are furnished with Louisiana heirlooms. A fourth-story cupola draws natural lighting into the house. The dining room is adorned with a fretwork beamed ceiling, reflecting Victorian grandeur of the late 1800s.

Among the canopy of moss-draped trees and exotic plants is the "Cleveland oak tree" named in honor of President Grover Cleveland, who journeyed to Jefferson Island on a hunting tour. The "Lafitte oak tree" is the site where a treasure of gold coins, buried by pirate Jean Lafitte, was discovered. After many years enjoying the southwest Louisiana paradise, Jefferson died in 1905 at the age of seventy-six.

The property changed hands in 1917 when Mr. J. Lyle Bayless Sr. and Paul Jones, both from Louisville, Kentucky, joined their hunting partner, E.A. McIlhenny, of Avery Island to buy Jefferson Island for its great hunting

opportunities. Bayless went on to develop a rock salt mine on the property in 1920.

His son, J. Lyle Bayless Jr., spearheaded the development of formal gardens of English style in a tropical setting on the grounds surrounding the Joseph Jefferson home in the late 1950s. Rip Van Winkle Gardens was established in honor of its former actor/owner and opened to the public in 1966. Bayless had a special penchant for camellias, incorporating three hundred varieties at Jefferson Island. Many improvements have been made to the gardens over the years, including the construction of a conservatory with rare tropical foliage. In 1973, a nursery was established next to the garden where hundreds of species of plants were grown.

Tucked into a grove of a dozen ancient oaks, Café Jefferson offers a spectacular view of Lake Peigneur from its glassed-in porch. Time can get away from you when dining in this peaceful setting. With tall ceilings in a bright setting and old lanterns on display, the café is open for lunch every day. Cajun favorites and seafood dishes are included on the menu. There's "hot from the oven" dinner rolls, po-boys, gumbo, shrimp remoulade, "Jean Lafitte salad" and many crawfish, shrimp and crab items. Among the enticing array of popular entrées are the Crab au Gratin and Crawfish Cardinale (cream soup with Louisiana crawfish, mushrooms and hints of cognac) and Eggplant Michelle (a tasty casserole of eggplant, shrimp and crabmeat). Desserts include crème brûlée cheesecake, bourbon pecan pie and chocolate mousse with Kahlua liqueur.

Another addition to this wilderness paradise is Rip's Rookery, home to twelve species of exotic birds. The rookery was formed by creating a natural habitat of ponds surrounded by cypress and maple trees when thousands of wading birds, including brightly colored roseate spoonbills, migrated from Lake Martin to Jefferson Island. The habitat is also sanctuary to many alligators.

The island survived an unbelievable catastrophe when on the morning of November 21, 1980, there were tremors on the grounds of Jefferson Island that changed the face of the island dramatically. Workers drilling for oil beneath Lake Peigneur punctured the mine at 1,300 feet—the lake actually began draining rapidly into the cavity of the salt dome, triggering a powerful, swirling sinkhole. An oil rig, a tugboat, sixty-four acres of the garden, Bayless's personal home, trucks, a greenhouse, trees and thousands of plants in the conservatory were pulled into the bottomless pit, sinking out of sight.

Not long after Lake Peigneur seemingly vanished it reappeared, as the brackish water of Vermilion Bay began gushing in to refill the lake area.

The Joseph Jefferson Mansion was built in 1870 on Jefferson Island. *Courtesy of Mike Richard.*

Nine of the eleven lost barges popped back up, while oil drums floated to the surface. Within two days, what had been an eleven-foot-deep freshwater lake had become a one-fourth-mile-deep saltwater lake. Miraculously there were no fatalities, although the gardens were closed for nearly four years. Visitors question why there is a brick chimney jutting out of the water. It's a remnant from the Bayless house that serves as a reminder of the disaster.

Following the Lake Peigneur mishap, the twenty remaining acres of Rip Van Winkle Gardens, now called Live Oak Gardens, were restored and reestablished with a new café, a conference center and bed-and-breakfast cottages. The grounds provide a romantic setting for sunset weddings.

Mike Richard took over the gardens in 2003. Originally from Cecilia, Louisiana, Mike is a graduate of the University of Louisiana–Lafayette in horticulture and studied landscape architecture at Louisiana State University. While a student, he worked as an apprentice at Live Oak Gardens beginning in 1969, gaining practical experience in landscaping while acquiring a green thumb along the way.

"It was a perfect opportunity to combine the academic knowledge and hands-on training," Mike said. Thus began more than forty years of Mike's relationship with the island as the head of horticulture at the gardens. He opened Jefferson Island Nursery in 1973 and personally experienced the

drama of the Lake Peigneur. "We thought the world was coming to an end," he offered. "We've had challenges of bad freezes during the winter and faced hurricanes, but none of these compared to the destruction of 1980."

Mike has brought new life to Jefferson Island with help from Mother Nature's perpetual mix of rain and sunshine. Year round there are colorful bursts of irises, wisteria, magnolias, hibiscus, azaleas, tulips, bougainvillea and numerous other flora. Whiffs of gardenias and roses lead you through a mélange of various gardens, linked by adjoining footpaths. The camellias that were planted so long ago provide showy, vibrant blooms in the winter. Mike is not afraid to try something new. Fifty different bamboo varieties have been introduced to the landscape. The Kauri tree, a type of pine tree from Australia, can be found thriving at Jefferson Island.

A muster of peacocks roams freely through the tapestry of plants and flowers, a legendary retreat of natural beauty offering serenity as it did nearly 150 years ago. Strolls through Live Oak Gardens, tours of the magnificent Joseph Jefferson Home and lunch at Café Jefferson are available daily throughout the year except for holidays.

IBERVILLE PARISH

St. Gabriel's Grocery and Deli

3495 Highway 75
St. Gabriel, LA, 70776

Iberville Parish was named in honor of the founder of Louisiana, Pierre Le Moyne, Sieur d'Iberville. The parish enjoys a bounty of historic communities. The first recorded Catholic mass in Louisiana took place in the Iberville community of Bayou Goula in 1700. The town of Sunshine was originally called Forlorn Hope after a plantation, although it changed to a more optimistic name a few years later. The area was settled by Acadian exiles who arrived in 1767 to help complete Fort St. Gabriel on Bayou Manchac. The town of St. Gabriel takes its name from the St. Gabriel Church—established in the 1770s making it the oldest surviving church structure along the entire Mississippi River.

St. Gabriel's Grocery and Deli in St. Gabriel has the "country store" smell as you mosey in through the swinging screen door and listen to the *tap-tap* of your shoes on the wooden plank flooring. At one time, you could stand on the porch of this two-storied, wood-frame building and watch steamboats on the Mississippi River running by. Documented to 1856, the store was originally part of the Monticello Plantation, owned by Joseph LeBlanc and his son, Simon, on property where the Houmas Indians formerly lived. The LeBlanc family were among the first Acadians to settle at St. Gabriel d'Iberville in 1767.

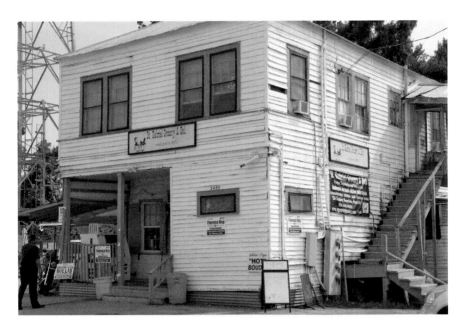

St. Gabriel Grocery, whose origin is documented as 1856, along the Mississippi River. *Photo by author.*

The old store is located twelve miles south of Louisiana's state capital, Baton Rouge, and is recognized as the last remaining of fourteen grocery stores on the east side of the Mississippi River. Groups of visitors love to take a drive to this roadside landmark, a throwback to old days.

As a sharecropper's store of the sugar plantation, St. Gabriel's had its own brass "stamped" coins. Workers of the land were paid only in plantation money, using it to buy their wares. The money was only good at St. Gabriel's.

This "one-stop" shop had feed and seed, shoes and clothing, eggs, elixir for ailments, hairbrushes, nails and bowls. There was a doctor's office, a barbershop and a place to wet your whistle. This was where you picked up your mail, as St. Gabriel's housed the first post office in Iberville Parish. The train station was nearby, with lots of folks boarding for travel to New Orleans, so St. Gabriel's was a good meeting place—and still is!

Wayne and Theresa Roy bought the store in 1987 from Aubrey Laplace. Wayne began working at the store when he was in high school in the early 1970s to learn the trade. His first paycheck was twenty dollars for a week of stacking shelves, mopping floors and bagging groceries. When the Roys took over the store, they strived to keep the hometown hospitality of St. Gabriel's, although they expanded the deli and stocked essential grocery

items like milk, bread and boudin. Their homemade meat sandwiches make it handy for commuters heading to chemical plants to stop by and pack a lunch. Other lunch items include hot dogs and hamburgers, hot sausage po-boys, salads and homemade treats like pralines and muffins. The inventory still includes the whole kit and caboodle.

Neighbors in the nearby community of Sunshine have a routine of cleaning out their barns and attics, sort of a spring cleaning of antiquities. When they find treasures like an old sewing machine or kerosene lamp, they have an inkling of what to do with their treasures. They scurry over with riches in hand to St. Gabriel's, making room on the shelf for one more antique and giving the place a living museum atmosphere. An old typewriter, an old-fashioned fan and the store's original 1910 cash register are strewn throughout. And there's more: old bottles, Louisiana State University football memorabilia from the 1958 championship, a collection of Christmas beer steins and early New Orleans Saints football posters.

Southern chef/master storyteller Justin Wilson, known for his "I gawr-on-tee" humor, came by often to St. Gabriel's Grocery 'cause it's such a happy place. He enjoyed the pleasant feelings of the store, becoming friendly with store owner Aubrey Laplace. Justin Wilson included a few humorous observations of the store in one of his cookbooks. There's also a photo of Aubrey Laplace and Justin Wilson sharing a mess of pork feet.

Most of all, St. Gabriel's remains a visiting spot along the levee. There is an old red coke box and plenty of chairs for sitting. Chips and coke or a cold beer for refreshments. And plenty of stories to go around.

JEFFERSON DAVIS PARISH

Rocket Drive Inn
1118 State Street
Jennings, LA, 70546

It's a blast from the past. The Rocket Drive Inn, complete with red picnic tables for outdoor dining and red-and-white checkered exterior, brings back fond memories of the old drive-ins. Launched in 1962, the Rocket was named in honor of the U.S. space program, as this was the year the first U.S. rocket landed on the moon.

That popular institution, the American drive-in restaurant, originated in the early 1920s in Texas when the Pig Stand, a barbecue-themed stand, opened on a busy Dallas highway to delight hungry customers looking for a unique curbside dining experience. After World War II, with more autos on the road, drive-in restaurants became very popular. Cars were big and roomy. Families liked the idea of eating dinner in their cars instead of at a sit-down restaurant. Kids loved it because they could go dressed in their pajamas to enjoy sizzling hamburgers, thick milkshakes and golden French fries.

After graduating from high school, JoAnn Leger, owner of the Rocket Drive Inn, began working for TG&Y, a local dime store. A few years later, she got roped into the food business. "I was thrown into it. I didn't know anything about running a restaurant, but I knew how to cook. Now I love

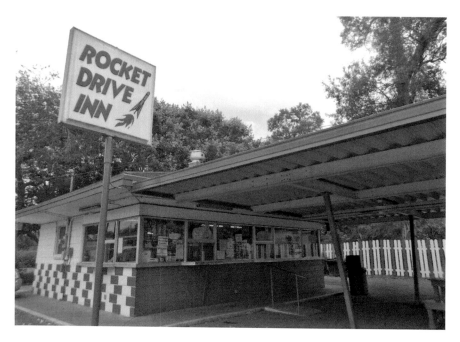

Hamburgers are number one on the menu at Rocket Drive Inn in Jennings. *Photo by author.*

it," she noted. Not much has changed over the thirty-five years that Jo Ann has owned the Rocket, save for a few facelifts.

"We have a large menu, but our specialty is hamburgers. We have people driving in from Texas to come here," she added. "We get orders called in on Wednesday nights ahead of time for Friday night burgers when the Jennings football team, the Bulldogs, play in town." Jo Ann noted that to prepare one order of one hundred burgers takes some planning, but everything is prepared fresh and cooked on the gas grill the old-fashioned way. "One of the secrets to preparing juicy hamburgers is the right timing of flipping them," she confessed.

Most mornings for JoAnn begin at 6:00 a.m. with breakfast, lunch and dinner served all day, every day. JoAnn's daughter, Olivia, is learning the essentials of doing it all—the cooking, ordering supplies, mixing and seasoning, shopping, taking orders, running the ice cream machine and cleaning up. The best part for JoAnn is mingling with customers during the lunch hour. "That's the fun part," she recognized.

The Rocket is rooted in the neighborhood. There's a school across the street and a bank on the other side with houses all around. A good-sized menu includes tasso sandwiches, homemade onion rings, hot dogs, Frito pies, grilled chicken livers, nachos, po-boys and baskets of hand-battered fried shrimp.

The little kitchen is busy with cooks filling orders. Ice cream is a good cool treat, including sundaes, banana splits and a dish of ice cream topped with bits of chocolate candy called a Rocket Blast. It's a neat side trip to the heyday of Americana, so roll your windows down and order a hamburger, served with a side of nostalgia.

W.H. TUPPER MERCHANDISE MUSEUM
311 North Main Street
Jennings, LA, 70546

It's as though the clock has stopped ticking for the W.H. Tupper General Merchandise Museum. It gives a "hands on" look into early twentieth-century life in rural Louisiana among French and German settlers who came to the prairieland of Jefferson Davis Parish when the railroad came through.

Jennings boasted a thriving farming community, with the Tupper family farm located on the outskirts of town. For rural families to get their supplies, travel to stores could be difficult. They had to plan their visits—whether on horseback, buggy or wagon—to come into town. To accommodate the flourishing agricultural community, Mr. Tupper built a small general merchandise store on his own farm in 1910. A post office was later added, with Mr. Tupper named as postmaster.

A general store made the country seem a little smaller by drawing in the outside world. New services were introduced through the general store, usually the first place in the neighborhood to share a working telephone. Newspapers were for sale, and a post office was set up to receive mail.

It served as a central meeting spot for everyone to get neighborly news and compare notes on crops. The smell of coffee grinding and a variety of spices greeted customers. Children were drawn to jars of bright penny candy. There was both ready-made clothing and, for those handy with needle and thread, colorful bolts of cotton fabric and buttons. Gentlemen gathered to inspect the newest tools that might make their work easier. Customers were excited to enter the welcoming atmosphere of the store, which usually had a potbellied stove to edge up to as they warmed up.

Tupper's stock included groceries, medicines, clothing, hardware, dry goods, fresh milk and a little bit of everything. During the Great Depression,

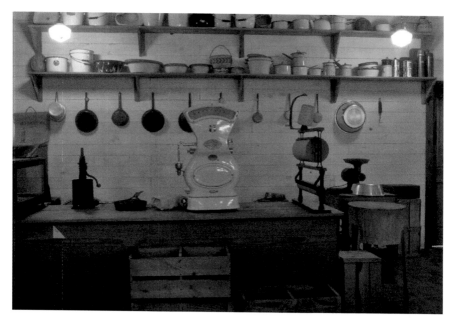

A look into old shopping customs at the Tupper Store and Museum. Courtesy of the Louisiana Department of Culture, Recreation and Tourism.

workers were often paid with "Tupper chips," which could be used to purchase goods at the Tupper Store.

As modes of transportation grew and people had more opportunity to get around, the store outlived its usefulness. Although Mr. Tupper died in 1936, his daughters, Agnes and Celia, and later their brother, Joseph, kept it going until they closed the store in 1949.

Everything was kept on the shelves as though time had stopped, until the mid-'70s, when daughter Celia Tupper moved everything to a warehouse, packing each item to carefully preserve it all. Clothing was dry-cleaned, and leather goods were oiled to protect these items from the past.

As a way for the family to share the treasures from the store, Tupper grandson Joe Tupper Jr. offered the complete contents of the warehouse to the City of Jennings to open a living history museum of a general store in 1989.

All of the items in the museum are original, including the cabinets, calendars and even the shopping bags promoting the sale of war bonds during World War II. Display boxes are filled with toys of yesteryear—Charlie McCarthy, Betty Field paper dolls, tea sets, bagged marbles and kewpie dolls. There is everything a properly dressed lady needed—dresses, gloves, Cinderella silk

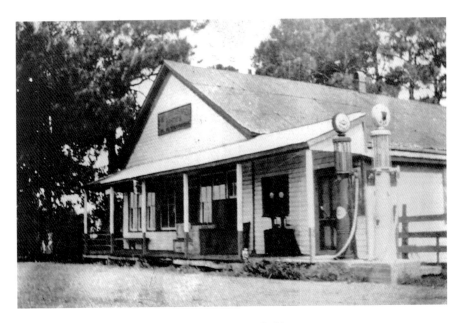

Original Tupper Store. *Courtesy of W.H. Tupper Merchandise Museum.*

hosiery, undergarments, dainty shoes, society hats and hatpins. An assortment of carefully folded vintage aprons is displayed on a table.

Among the most prized possessions in the store is the collection of Native American pine needle baskets of the Chitimacha and Coushatta tribes, well-known for their intricate designs.

Visitors to the Tupper Museum step back through a few eras at an exhibit of hundreds of pantry items—Dr. Pepper, Community Coffee, McCormick's House Tea, Top Hat Syrup, Ovaltine, Colgate Tooth Powder, cans of fruitcake, the tonic Hadacol and various sundries. In the early days, built-in drawers and bins displayed sugar, coffee, flour, spices and dried beans, all of which were sold by the pound.

There are coffeepots and chamber pots, dishes, tools, paintbrushes, farming supplies, hair pomade, cigars, Cutkeen knives and Buescher's Hickory Pipes. Many items have the original price tags.

It's a history lesson that children and adults enjoy with unbelievably preserved items from each era between 1910 and 1949. When you spot an original 1913 calendar posted on the wall, you will feel you are actually present in the time when Woodrow Wilson was America's twenty-eighth president, a dozen eggs cost thirty-seven cents, the Panama Canal opened and Henry Ford developed the first moving assembly line.

LAFAYETTE PARISH

ALESI PIZZA HOUSE
4110 Johnston Street
Lafayette, LA, 70503

Truly connoisseurs of good eats, the Cajuns of southwest Louisiana are familiar with every kind of gumbo, seafood and stew. But when it came to pizza, they had no clue. At least until 1957, when Mariano "Mike" Alesi introduced pizza, lasagna, ravioli and other traditional Italian dishes to Lafayette and Cajun Country. He advertised his "Pizza Pie," although his customers innocently asked, "Just what kind of fruit is actually in these pies?"

Mesmerizing children through a glassed-in pizza kitchen, the Alesis still perform a show of tossing and spinning pizza dough in the air. Tossing it manages the moisture in the dough by stretching it out. After it is rolled, punched and slapped, the dough is then formed in a round shape before it is haphazardly flung in the air and carefully spread out to fit in the pan. The hallmark dish of Alesi's remains its pizza, prepared in the traditional Sicilian style with fresh dough every day and covered with a slow-cooked, tomato-based pizza sauce. One of the most popular pizzas on date night is Pizza La Mike, considered a pizza for "two in love," piled with layers of cheese, pepperoni, bacon, mushrooms, bell peppers and onions. It's accompanied by an antipasto salad of salami, provolone cheese, ham, olives and anchovies on a bed of lettuce.

A colorful map of Italia and shelves of imported wine grace the entrance to Alesi's. An early menu shows popular Italian dishes along with a special pasta dish created to please the Cajun population: crawfish spaghetti. The dining room is circa 1970s, with lattice-framed booths and hanging globes for mood lighting.

Mike's parents, Girolamo and Marianna Nazione Alesi, emigrated from Sicily to Detroit, Michigan, via Ellis Island to join other family members. During Prohibition, several storefronts were opened with two-fold operations, and the Alesis had one of them. Their upstairs candy store had chocolates and confectioneries in glass cases. But more action was happening downstairs, where customers played pool and bought beer. The Detroit River—bordering between Ontario, Canada, and the United States—was one of the busiest waterways, presenting opportunities for rumrunners and bootleggers to get booze from Canada into the United States. The city of Detroit was a prime location for hosting speakeasies called "blind pigs" that sold beer behind the scenes.

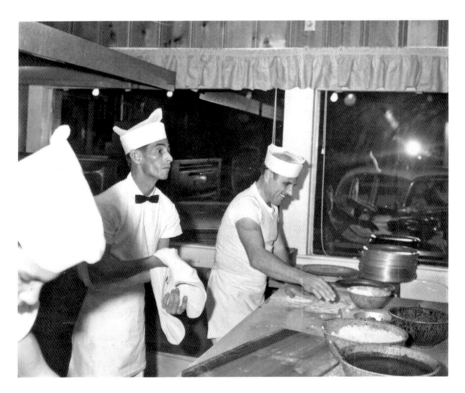

Mike Alesi tossing pizza. *Courtesy of Alesi Pizza House.*

For a fresh start, the Alesis moved to San Diego, California, in the early '40s. After Mike was drafted into the army during World War II, he was stationed in Lafayette at the U.S. Air Force Base, which is now the Lafayette Regional Airport. Ever a smooth talker, he met Bertha Rose Mouton from the nearby community of Milton working at a dime store in downtown Lafayette. After a short courtship, he convinced her to marry him and move to San Diego, eventually adding four sons to their dynasty, all born in California.

Since family members had experience in the restaurant business, Mike and his parents opened the Log Cabin Restaurant in Alpine, a suburb of San Diego. Diner-style cuisine was offered, not Italian. To help with expenses, Mike formed the Mike Alesi Band, playing his accordion for weddings as a sideline job to support his growing family.

Mike and Bertha Rose always hoped to return to Lafayette, and after fifteen years with the Log Cabin, they relocated. For a short time, Mike dedicated himself to learning how to make pizza at Uncle Angelo's pizza parlor in Detroit. Family recipes were collected as he learned the business, recognizing that the secret to success is in the sauce.

Mike's son Mike Jr. was eight years old when the family moved to Lafayette. It was memorable because on the long drive home, the family traveled the countryside. This marathon road trip included a drive through Louisiana's Cameron Parish just days after Hurricane Audrey had blown through, with winds causing mangled trees, smashed structures and unbelievable destruction. After experiencing California's scenic countryside and ideal climate, Mike Jr. questioned the wisdom of a move to Louisiana. "Why are we coming here?" he asked.

In Lafayette, the Alesis opened a small restaurant on Cameron at Bertand Streets featuring weekend breakfasts and three meals a day, diner-style, for five years. With the increasing popularity of Alesi dishes, a new and larger Alesi Pizza House was built on Johnston Street in 1962, tagged as "Lafayette's Original Restaurant and Pizza House." Sons Mike Jr., Charlie, Jerome (now a dentist) and Tommy (now a drummer with the Cajun band Beausoleil) grew up working in the restaurant. The family lived across the street. The spaghetti sauce was truly prepared "home-style," as Bertha Rose cooked the sauce at home and carted it over to the restaurant many hours later.

Italian specialties aside from pizza include lasagna, spaghetti and meatballs, eggplant parmigiana and manicotti. You can also order a steak broiled to your liking. To finish off your meal, famous desserts from Angelo Brocato's of New Orleans are available. Savor the taste of

Alesi's introduced pizza to Cajun Country in 1962. *Photo by author.*

spumoni, a colorful, three-flavored ice cream of strawberry, pistachio and vanilla. Cassata is the same as spumoni, though prepared as a "dressed up" cake.

Today, Alesi's is managed by sons Mike Jr. and Charlie. The founders, Mike and Bertha, both died in 2010 a few months apart. According to

Mike Jr.'s son, Mari Alesi, third generation, who is learning the ropes, "We make our own sauce and fresh dough every day from family recipes."

Grandson Mari remembered that his first job at Alesi's was bussing tables. Then he progressed to waiting on customers and taking orders. "Nearly all of the Alesi children have worked here. If you are an Alesi, there is tomato sauce in your blood," Mari commented.

He has fond memories of his grandparents, who routinely treated the kids on summer trips to Six Flags. "I take pride in what my grandfather did. We like to keep the traditions he started."

KELLER'S BAKERY

1012 Jefferson Street
Lafayette, LA, 70501

It's a gift that has been handed down through five generations of bakers. For eighty-five years, Keller's Downtown Bakery has crafted confectioneries ("Being Sweet to You Is Our Business").

Situated on what was once named Oak Avenue and is now called Jefferson Street in downtown Lafayette, the Bakery building dates back to 1948. The storefront has a cheery feeling, with a dazzling display of petit fours, coconut macaroons, cream puffs, fig fruit bars, brownies and more—truly a sugarplum fairy's dream to treat the taste buds.

Once bakers in the Alsace region of France, the Keller family was influenced by both French and German methods of baking fine pastries. Carrying recipes from the old country, they immigrated to America in 1760. Victor Keller was the first to open a Keller's Bakery in the United States, in the small town of Abbeville, Louisiana, in 1895. Once his son, Florian, learned his way around cakes and cookies, he married an Abbeville girl, Mary Ella Hollier, and a second Keller's Bakery was opened in 1920 in New Orleans.

Following the family's business way, Florian's son, Fenwick, and his wife, Eleanor, moved from New Orleans and opened their own bakery in 1929 in Lafayette, the same year the Great Depression began. Fenwick was only nineteen and Eleanor seventeen. They had $400 in their pockets, a pickup truck, a big dream and a gift from the Kellers: recipes. They baked French bread, doughnuts, assorted pies, cakes and cookies, and Eleanor added her own flourish by decorating the cakes herself.

Fenwick and Eleanor's son, Kenneth Keller, started managing the bakery in 1973, becoming the sole owner in 2004, although his daughter, Ashley, and son, Nicholas (sixth generation), are learning the business of sweets. He admitted that in every business there are ups and downs, although be assured that the dough rises every morning in the Keller's kitchen. During the early 1980s, Lafayette depended on the oil industry, experiencing a downturn that affected the local economy, especially small businesses. Many large grocery stores opened up their own bakery departments, bringing in more competition. At one time, Fenwick wanted to add something salty to the list of baked goods, so he experimented with kibbehs, a Lebanese dish shaped like a meatball of ground meat or lamb. Although the timing was not right for this particular dish, it did lead to Kenneth successfully preparing the meat pies many years later that Keller's now serves.

If you were a Keller and could count up to twelve, your job became bagging butter rolls by the dozen. Once you had accomplished that task, your next job was assembling cardboard boxes used for cookies and cakes. The bakery became a lifestyle; the Keller family lived upstairs, which was convenient for the workdays that began at 2:00 a.m. Ovens were warmed up, orders were checked and the baking began. Usually by noon, racks of pies, cakes and cookies were cooling.

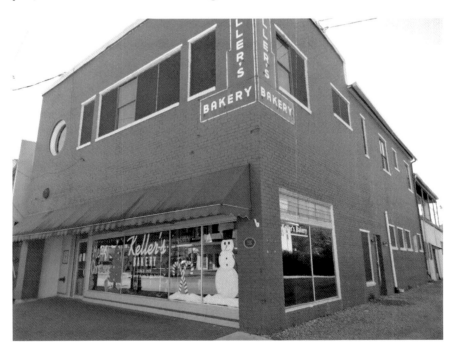

Keller's Bakery opened its doors in downtown Lafayette in 1929. *Photo by author.*

In the early days, Keller's sweets traveled all over country roads. Drivers were assigned to a route to deliver fresh-baked pies to restaurants and cookie assortments were delivered to mom and pop stores. Specialties in the Keller's cooler are rum cakes, cheesecakes and strawberry shortcakes. The "take and bake section" has biscuits, potpies, bite-size pies filled with meat or crawfish and quiches. Keller's cakes have starred at thousands of weddings, birthday parties and other celebrations.

Without question, the most festive time at Keller's is not Christmas, but Mardi Gras. The first Mardi Gras in Lafayette was celebrated in 1897, when King Attakapas reigned over a carnival ball. The Carnival season of feasting and fun actually begins on the Feast of the Epiphany or Twelfth Night (January 6 of each year). This is the night the three kings arrived with gifts for the Christ child. The season continues on through Fat Tuesday, the day before Ash Wednesday. Mardi Gras, French for "Fat Tuesday," serves as the final bash for making merry before Catholics begin the Lenten season. The Mardi Gras season is celebrated royally for several weeks, filled with a frenzy of balls, masquerading, parades, the tossing of beads and doubloons.

The most delightful icon of Mardi Gras is the king cake, brought to Louisiana from France and Spain in the eighteenth century. A king cake is made from braided strands of cinnamon dough shaped into an oval ring and decorated in the Mardi Gras colors of purple for justice, gold for power and green for faith. The recipe that Keller's Bakery uses for its handmade king cake dates back more than 120 years.

Each cake is rolled and twisted, proofed (allowing the dough to rise), filled and then baked. Surprisingly, Keller's had a slow start when it introduced king cakes in the late 1980s; it baked only six for the first season. Now the king cake is considered a treat synonymous with Mardi Gras, making this the busiest time of the year for Keller's. Fans take this delicious dessert seriously—Keller's produced a total of fifteen thousand king cakes for the 2014 season. Although the original flavor was butter pecan, now you have fifteen choices, including blueberry cream cheese, strawberry banana split, cinnamon apple cream cheese and amaretto walnut cream cheese.

There's a surprise inside. A small plastic baby, representing the Christ child, is available to be inserted in the baked cake. Once the cake is sliced, the person who is served the slice with the baby inside must provide the next king cake or host the next Mardi Gras party. The Louisiana king cake is similar to the brioche-based cakes of southern France named *gateau des rois*, also with a hidden trinket.

A popular icon of Mardi Gras, the king cake. *Courtesy of Keller's Bakery.*

It's a tribute to the quality of Keller's king cakes that they have been served at elegant Washington, D.C. Mardi Gras parties, as well as at the White House during President George W. Bush's term. A king cake can be baked on a Tuesday morning in Lafayette, shipped out in the afternoon and served at noon on Wednesday in another state. It ships king cakes all over the United States, often for transplanted Cajuns hosting Mardi Gras celebrations.

Fenwick Keller had plenty of good ideas, and one was that the best advertisement for the bakery was surely the sugary smell of fresh-baked cookies drifting down the street.

JUDICE INN

3134 Johnston Street
Lafayette, LA, 70503

A pair of farm boys had the notion of opening a hamburger stand on family property. Now a Lafayette institution, the Judice Inn is known for the "Best Hamburgers in Town Since 1947."

Brothers Marc and Alcide Judice grew up in a family of seventeen on a farm in Lafayette, once considered "the country" though now part of the hustle and bustle of the city. Strong work ethics came from rising when the rooster crows, toiling in the hot sun in dusty fields and not fighting with others (they were a family of seventeen after all). Five Judice brothers served their country during World War II, and they all came home safely.

Our love affair with the classic hamburger began in the 1880s, when the "hamburg steak" was brought over to America. During World War II, this popular sandwich was dubbed the "liberty steak" to avoid using the German-sounding name of "ham-burger." It became an inexpensive and easy dish to prepare.

Upon returning to Lafayette after the war, Marc took up a job selling at Lafayette Hardware, and Alcide joined the railroad. Meanwhile, the brothers were planning to build something long-lasting. Family property was available on Johnston Street when it was not much more than a gravel road, and thus Judice Inn was born.

Armed with hammers and nails, the family of seventeen, plus loads of Judice cousins, built the small drive-in. They introduced and still maintain a simple menu focusing on memorable, mouthwatering hamburgers and cold beer.

Yellow booths over black-and-white checkerboard flooring give character to the setting, a throwback to the old days where little has changed. Minor modifications have been made to the restaurant only because of unexpected happenings. When a car crashed into the restaurant more than thirty years ago, repairs were made and dining space was added. Further modernization took place when a fire occurred in the cubbyhole of a kitchen.

Burgers are slathered with a secret sauce, concocted from a family recipe from the early 1940s. Both novices and longtime customers like to play the guessing game of what's in the secret sauce that gives that special kick. But the Judice lips are sealed—it remains a family secret. A scattering of grilled onions and a layer of cheese are tasty additions to the burger.

If you can snag a seat at the counter, you will see plenty of action from Marc's son, Gerald Judice, flipping burgers at the flat-top griddle. Gerald was initiated into the fine art of making burgers when he was ten years old and worked alongside his brothers and cousins. To Gerald it became a second home. He enjoyed the roughhousing with family mixed in with serving customers. In charge of sweeping the parking lot at first, he gradually helped with carhopping and waiting on tables, working his way up into kitchen, where today he is general manager.

Judice Inn has been making hamburgers with a secret sauce since 1947. *Photo by author.*

When Gerald was old enough to drive, he saved his paychecks from work to buy his own car—a snazzy Datsun 200SX for sporting around town. If you wanted something, you had to work for it and save up, according to his father's doctrine.

In the early days, Judice Inn was open seven days a week, closing only five days a year for holidays. In the mid-1970s, they began closing on Sundays, allowing for family time— the Judices all had big families. At the end of the day, when the restaurant was locking up, a head count of all the Judice mop tops was taken to assure that none was left behind.

Gerald graduated from the University of Louisiana– Lafayette in finance. Although he has worked at Judice Inn most of his growing up years, he did venture out of the business for a while to get a taste of what life was like "out there." When Marc became ill and Uncle Alcide died, Gerald stepped back in as though he had never left.

The original Judices came up with a great formula for cooking a killer hamburger, but they also forged a sense of integrity. Always do your best at any job was their advice, even if sweeping. Even today, many of the Judice cousins fill in when needed, lending a helping hand, so familiar are they with every aspect of the restaurant. Your waiter may be a lawyer, doctor, banker, engineer, teacher or nurse during the busy times. The employee with the longest time on the job is cousin Ashton Landry with forty-five years.

As a testament to humble origins, Judice Inn is a popular hangout for kids, especially following high school or college sports events. This is not a sports

bar. There are no big screen TVs or space for a jamming jukebox here. It's swell to eat at an old-fashioned café where the burgers are flat-out delicious. Looking out across the street is a modern movie theater, once the site of the Twin Drive-In Theater, where families piled up in their station wagon to watch John Wayne as the hero in a "shoot 'em up" western.

A few years ago, *USA Today* polled food experts to name "51 Great Burger Joints" in America. Judice Inn was chosen as the best in Louisiana for its classic all-American sandwich, the hamburger, with a Cajun twist.

Why no French fries on the menu? Hamburgers and French fries were not a popular pairing when the Inn first opened. Potato chips accompany hamburgers at this spot. And for a sublime cool treat, root beer floats and old-time milkshakes are served up. The "built-in character" comes with every meal!

CAFÉ VERMILIONVILLE

1304 Pinhook Road
Lafayette, LA, 70503

It's fine dining in a romantic atmosphere that predates the Civil War. A glorious past filled with twists and turns contributes to the mysteries of Café Vermilionville. A two-story structure of Green Revival style, it is considered Lafayette's first inn in the original area that would have been the town center of what was once called Vermilionville. The city became known as Lafayette in 1884 in honor of American Revolutionary hero the Marquis de Lafayette, who was visiting the United States at the time.

How did settlers choose where to put down roots? An abundance of natural resources, especially the vicinity of a waterway such as the Bayou Vermilion, was integral. It's where traders gathered, having traveled by boat for the exchange of merchandise with Native Americans, ranchers and fur trappers. The river landing near Pin Hook Bridge was important to the development of the region, serving as a crossroads for transportation from north to south and from east to west. Further growth was temporarily hampered by the difficulties of navigation through obstacles of submerged logs and stumps. Between 1840 and 1850, the Parish Police Jury took action in clearing the river to allow steamboat traffic up to Vermilionville by appropriating $4,000 for dredging.

Café Vermilionville in the 1950s. *Courtesy of Lafayette Parish clerk of court Louis J. Perret.*

Waterway capabilities were improved, ensuring further development. Plantations of cotton and sugar cane flourished along the river. Several businesses thrived, providing necessary goods for farmers and plantations owners such as cypress cisterns, molasses barrels, hickory chairs and spinning wheels. A lumberyard, saloon and billiard parlor, as well as a famous fried chicken restaurant, also filled their needs.

With increasing activity along the bayou, it was time to formally establish a town center. When a commission was appointed in 1823 to choose a site, landowners John and William Reeves from North Carolina donated two arpents of land where government buildings could be

erected. The brothers already owned a store. John had previously been granted a license to operate an inn at Pin Hook, possibly the structure now known as Café Vermilionville or the site where it is set. A jail was built on the Reeves property by the police jury, and a room was rented near the bridge to accommodate a temporary courthouse.

An opposing faction had other plans a few miles away when Jean Mouton donated land with the intent of building a Catholic church where St. John's Cathedral now stands. He envisioned growing the city center around the church, which was surrounded by great live oaks, and not on the banks of the Bayou Vermilion. The decision of where to establish the city was put before the voters in an 1824 election in a heated contest. When people chose the Mouton site as the parish seat, the Reeves plan was abandoned. In time, both the downtown—in which Mouton laid out a grid of lots and streets—and the Pin Hook areas grew.

In 1853, Henry Louis Monnier, a Swiss farmer looking for opportunity, purchased the property that Café Vermilionville sits on to develop as a plantation (there is evidence that there was a dwelling located at this site), while accumulating six hundred acres from surrounding landowners. At the same time, he established a store, becoming a successful merchant in what is now considered downtown Lafayette. The struggles of the Civil War greatly affected his livelihood as well as his personal life. He lost two sons at the Battle of Shiloh on the same day in 1862. Through this reversal of fortune, he experienced a tremendous loss of assets, confiscated or destroyed, and had insufficient labor to work his fields. There were two battles in 1863, in April and October, in which the Pin Hook Bridge was set afire by Confederate soldiers to prevent advancement from Union forces. During one of these skirmishes, the Monnier plantation home was occupied by Union troops. Following the hardships of the war, Monnier subdivided the property in 1870, selling it to his sons, Homer and Auguste (who became mayor of Vermilionville in 1873).

The property exchanged hands again when the Girard family purchased it from the Monniers, converting some of the property into a plant and flower nursery in 1882. In 1939, Maurice Heymann bought the property for multiple uses, including continuing the nursery and converting some of it into a shopping center. This development dramatically changed the future of Lafayette with the conception of the Heymann Oil Center, a "business community" housed by leading oil companies. During this time, plans were made to tear down the former inn/plantation home because it was in disrepair, but Horace B. Rickey Sr. saved it, restoring it as his home.

One of his more remarkable additions was a 640-square-foot master suite, called a garconnier, now used as the Café's lively cocktail lounge. A striking collection of six hundred miniature bottles of a variety of spirits from around the world is displayed.

Café Vermilionville is a classic building that has stood the test of time and miraculously survived—through the Civil War, the Flood of 1927, numerous hurricanes, sightings of ghosts and various states of disrepair. The style of the Café is classic Greek Revival. A Creole French element includes the upstairs hall-less floor plan that is now used for offices. An Anglo-American characteristic includes the presence of Greek Revival mantels, all four of which have survived. The distinctive atmosphere of a past era has been retained, even through many renovations. The front is graced with a five-bay colossal Doric post gallery.

There's romantic appeal in every square of the sky-blue foyer, adorned with hand-crafted cypress beams and flooring. There are double porches on each floor. The walls of the original section of the Café were built in the French Louisiana technique of mud and moss (bousillage). The structure, recognized by the Lafayette City-Parish Register of Historic Properties, is also called Vermilion Inn because it is believed to have been an inn at some point (circa 1835). Separate dining rooms enjoy distinctive lighting, setting a relaxing mood. For outdoor dining, a brick-lined patio provides a backdrop to feature local musicians on Wednesday nights.

Today's owners, Ken and Andrea Veron, are as passionate about the heritage of the building as they are about their culinary contributions to the Café. Ken's father, Ken "Poncho" Veron Sr., had a prior business interest in a few clubs in Lafayette. In purchasing the building in 1981, when it was a popular social spot called Judge Roy Bean's Saloon, he transformed it into a restaurant with a menu focusing on Cajun dishes.

Ken Jr. was thrown into the family business, taking on several tasks; his first was mowing the lawn during summer break when he was fourteen. He experienced more on-the-job training such as being dishwasher; he was gradually given the opportunity to work with customers, moving up to bussing and waiting on tables. He became general manager of the Café for a time until he ventured out on his own to dabble in real estate.

Andrea learned the ins and outs of the hospitality industry by working her way in restaurants while attending college, eventually opening an interior design business, which is her background. These experiences led to her volunteer service as a board member on the Lafayette Parish Preservation Commission, a government arm that protects buildings and districts in

Lafayette's first inn, Café Vermilionville, a survivor of the Civil War and the Flood of 1927. *Photo by author.*

Lafayette Parish that are of historical or cultural significance. Her interest in historical preservation and flair for decorating are a perfect fit for a landmark more than 170 years old.

In 2011, Ken and Andrea were offered the opportunity to take over management of the restaurant, something they had never planned on. Both are great cooks and can fill in where needed—as hostess, bartender, cook or working on the line in the kitchen if necessary.

Ken acknowledged that although the first menus were influenced by popular Cajun dishes of the 1980s, including blackened fish, new dishes have been upgraded for fine dining selections. The menu blends old school with contemporary tastes. Featured are classics from thirty-year recipes like steak Louis XIII (prime six-ounce filet mignon stuffed with crawfish tails, bacon and cheeses, finished with a wild mushroom demi-glace and crawfish Mornay sauce), short ribs with dumplings and fresh fish dishes, although the chef has incorporated some original recipes also.

The starters include crawfish beignets, a spicy blending of Louisiana crawfish tails, deep fried and dipped in Creole mustard, as well as turtle soup with chopped hard-boiled eggs and accented with a taste of sherry. Stunning desserts like key lime pie, banana foster cheesecake and white chocolate bread pudding are prepared to the delight of customers.

"It's like hosting a party every day," Andrea said. "Every morning we make sales calls and check on orders. By lunch, we come into the restaurant, survey the kitchen to make sure everything is running smoothly." The couple recognized early that "all of our customers are VIPs."

They agreed that "Mardi Gras is one of our favorite times. We really throw out the red carpet for the krewes." It's a fairy tale setting for celebrations. Enjoying a warm ambiance in a historic backdrop, Café Vermilionville is a popular scene for business dinners, rehearsal suppers and wedding receptions, as well as for a table for two.

BORDEN'S ICE CREAM SHOPPE

1103 Jefferson Street
Lafayette, LA, 70501

Three scoops of ice cream. Vanilla, strawberry and chocolate mounds nestled between a fresh banana sliced in half. Add a few spoonfuls of juicy, diced strawberries. Spray curls of whipped cream. Throw on some walnuts and drizzle with maple syrup. Top off with a cherry.

That's how Borden's in Lafayette, the last remaining Borden's Ice Cream Shoppe in the United States, prepares its banana split. There were once one hundred Borden's storefronts in the country. It's a sweet scoop of nostalgia as the landmark caters to generations of its first customers.

The shop, known then as an ice cream parlor, was built in 1940 in the downtown area. Dairy farmers drove in, some by truck and some by wagon loaded with cans, to take milk to the Borden plant and cooling station, once located behind the ice cream shop. The milk was then transported seventy-five miles west to Lake Charles for processing. Once the milk bottles were filled, they were returned to Lafayette. The town's milkmen lined up to pick up their crates of orders for early morning route deliveries. In 1960, Borden's built a new plant a few miles away while keeping the ice cream shop open.

In the early days, there were twenty-five flavors of ice cream served, although vanilla has remained the favorite at Borden's. A scoop of ice cream was only a nickel in the '40s. On display are old advertising posters featuring Elsie the Cow, who was introduced as Borden's mascot in 1938, making her

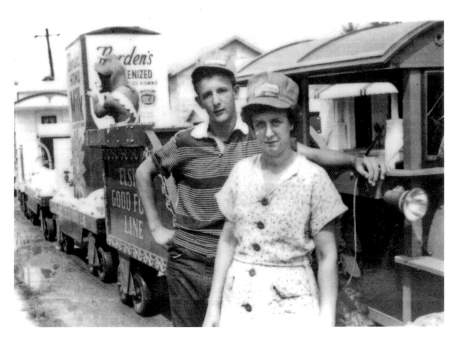

Borden's Ice Cream Train, promoting Elsie the Cow. *Courtesy of Lafayette Parish clerk of court Louis J. Perret.*

first live appearance at the 1939 World's Fair in New York City. So popular was Elsie that fan mail was addressed directly to her.

Across the street from Borden's were once homes filled with children who skipped across the two-laned road to the shop for a treat. When it was report card time at school, those with good marks were first in line for a scoop.

Ella Mae Meaux, chief fountain clerk, has served ice cream here for fifty-three years. She has enjoyed seeing her customers grow up and return. Many request that only Ms. Ella wait on them to prepare their banana split because she has that special touch.

Five years ago, Red Lerille, successful owner of a premier health club in Lafayette, and his daughter, Kackie, bought Borden's to keep the tradition alive, overseeing extensive renovation. The interior Art Deco style maintains the ice cream parlor look of the past. Inside the old-time shop are red booths to slide into, and the red neon Borden's sign lights up in the evenings.

Judging by the smiles of children who visit Borden's, they love the variety of ice cream dishes you can sample—dip cones, thick milkshakes, sundaes, sherbet flips and freezes and Coke floats, all made the old-fashioned way. Borden's opens early for coffee and muffins, but not just for a plain cup of

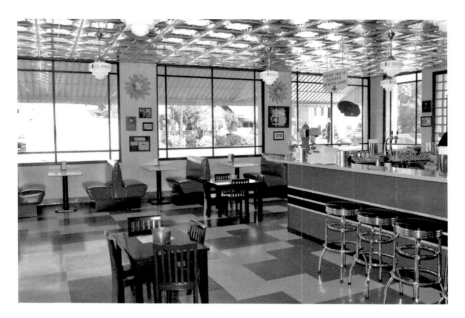

The last remaining Borden's Ice Cream Shoppe in America. *Courtesy of Kackie Lerille.*

java—also available are espresso, cappuccino and café au lait. Outdoor seating is an option for lunch, when hot dogs and Frito pies are dished up. Hot chocolate comes out steamy because even Louisiana has some snuggle-up weather.

Borden's is located directly on the routes for Lafayette's Mardi Gras and Christmas parades. It's a favorite backdrop for posing for photos—truly a blast from the past. As you slide up to the counter, you may remember this was where you came with your family for dessert every Saturday or splurged on a sundae with Elsie the Cow smiling over you.

OLDE TYME GROCERY

218 West St. Mary Street
Lafayette, LA, 70506

It's known as the little grocery store with the big poor boys. Lafayette's Olde Tyme Grocery has been "Making Poor Boys Famous Since 1982." And what is a poor boy?

It originated in New Orleans, similar to a submarine sandwich but equipped with a Louisiana touch: crusty French bread. In the early 1920s, brothers Bennie and Clovis Martin worked as streetcar conductors with dreams of opening a restaurant in the French Market of New Orleans. Because of labor disagreements, a large group of streetcar workers, also friends of the Martins, began a transit strike in 1929. The brothers generously lent their support to their former colleagues by feeding them foot-long sandwiches of their own making. Crammed with a choice of cheese, meats or seafood and dressed with lettuce, tomatoes and mayo, those famous sandwiches were handed out freely to those "poor boys" on strike.

In the early 1980s, Glen Murphee relocated from New Orleans to Lafayette to attend what is now called the University of Louisiana–Lafayette. He invested in a small grocery store called L&G Grocery, located an easy walk from campus. The one-hundred-year-old wood-frame building also had an apartment. On his birthday, Glen moved in and became the proud, though inexperienced, owner of a mom and pop grocery store, complete with an assortment of canned goods, a deli case, produce and five small shopping carts. With the proximity of hungry college students, he considered which would be more popular—hamburgers or sandwiches. Because of his New Orleans background, he chose to make meat poor boys, though experimenting by preparing only fifteen a day at the beginning.

Murphee took advantage of the community's predominantly Catholic population, recognizing that during the Lenten season, many Catholics abstain from eating meat on Fridays. More options for seafood might prove to be a good idea. Business was good with the meat poor boys, so Murphee bought a fryer and began making "fried shrimp" poor boys. His poor boys used an "alligator skin" soft French bread, nearly a foot in length, instead of the New Orleans crusty type.

There are no longer groceries in the store; instead it is stocked with essentials of potato chips, soda pop and beer to accompany the sandwiches. Indoor dining and an outside patio are ideal as a haunt for both college students and businessmen. The weekends draw in plenty of visitors to Lafayette, especially during spring's Festival International, which is held in downtown, an easy walk to Olde Tyme Grocery. As a free celebration of the French cultural heritage, the festival showcases music, cuisine and arts and crafts with French, African, Caribbean and Hispanic influences. During another popular celebration, Mardi Gras, Olde Tyme is a handy spot for catching beads. "Throw me something, mister" is heard in Lafayette throughout carnival season.

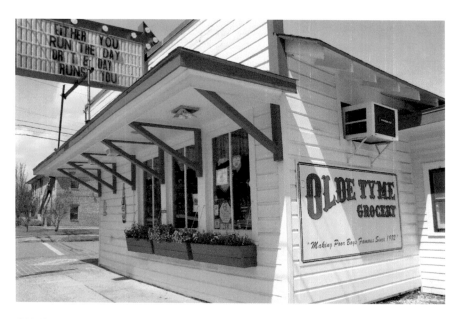

Olde Tyme Grocery, famous for its big poor boy sandwiches. *Photo by author.*

Patrons enjoy a basic menu with "funky" additions, such as during Discovery Channel's "Shark Week," where the chef fashioned a "blackened shark poor boy." It has done a takeoff of a popular sandwich from another region: the "chicken philly poor boy," a marinated chicken breast covered with sautéed onions, bell peppers, jalapeño mayo and Swiss cheese. And roll up your sleeves for the sopping juices of the rib-eye poor boy. The wedge-shaped, homemade French fries are a good pairing to any of the poor boys. Whenever there is a "Ragin Cajuns" football game (mascot of the University of Louisiana–Lafayette), fans come in to celebrate.

A few years ago, Murphee borrowed another idea from New Orleans. It's no surprise that summer days are long and hot in Louisiana. To give both little and big kids a cool respite, a snowball stand was opened adjacent to Olde Tyme. A blue tongue is evidence that bubblegum is a favorite flavor. The original snowball of shaved ice topped with sugary syrups was invented in New Orleans in the 1930s.

The Annual Poor Boy Eating Contest is not for amateurs. Hungry contestants must eat an Olde Tyme special within ten minutes. The sandwich is a two-handed wonder, weighing nearly five pounds. It's a hearty combination of ham, turkey, roast beef, Swiss cheese and dressing. There's a laidback vibe to Old Tyme that beckons to road trippers.

Creole Lunch House

713 12ᵗʰ Street
Lafayette, LA, 70501

There's a few blue plate specials (count 'em, six) every day at the Creole Lunch House. Set on a shady street across from a small Catholic school in one of the oldest neighborhoods in Lafayette, the restaurant hosts an amazing variety of dishes. There are barbecue ribs, fried pork chops and fricassee jam-packed with plump, juicy meatballs, to name a few. And Friday is dedicated to seafood—fried catfish or shrimp and catfish court-bouillon.

One of the signature dishes is smothered chicken and sausage with okra. It's a popular one-pot dish prepared with layers of herbs and spices. The meats and vegetable are tenderized by a "smothering" technique of simmering in a covered pot with a little liquid for hours. Once the "meat falls off the bone," a term you hear often in Cajun cooking, it is served over rice. As a hand-me-down vegetable from farmers and field hands, the revered okra has a long history in Louisiana. A little slimy but very versatile, okra can also be prepared pickled, breaded and fried, as well as added to gumbo for thickening. The word *gumbo* is derived from the West African term for okra, which was transported to the Americas through the transatlantic slave trade.

It's like showing up at Mama's house. It is actually a house turned café, fitted with a charming setting of peach-colored walls, lacy curtains and yellow patterned tablecloths. Tacked to the wall is a community bulletin board for sharing local events. The front door stays open if the weather is nice. There's extra seating outdoors in the shade.

Lunches are hefty, and diners eat clear to the bone if it's chicken or ribs. Bliss comes from the tangy side dishes like mustard greens, lima beans, black-eyed peas and cabbage. The only sounds you hear are lips smacking and big metal spoons scraping the cooking pots on the stove.

Creole Lunch House owes its success to the moxie of owner Merline Herbert, who grew up near the area known as "Four Corners" in Lafayette. Her background stems from business owners. Her husband owned a janitorial service, and her father had a furniture moving company. Merline was a schoolteacher for nineteen years and a principal for three. Upon retirement, she was ready to try something new, out of the classroom. She credits her cooking skills to her mother, with time spent working together at the stove to perfect her rice and gravy, a "must" in Cajun Country. When she began preparing plate lunches in 1983, she recognized that you couldn't offer a complete meal unless you served it on rice. Some parts of the country

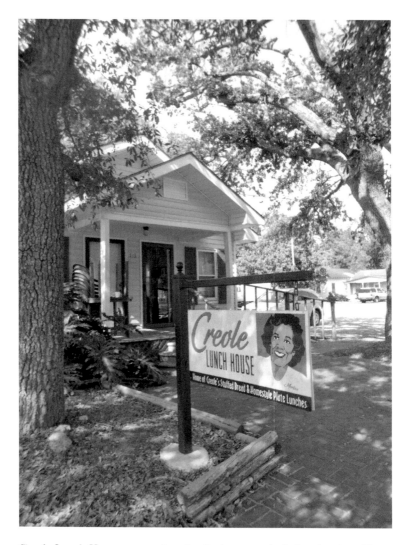

Creole Lunch House, a casual setting for home-cooked plate lunches. *Photo by author.*

depend on potatoes, but in Cajun Country, the focus is on rice immersed in a rich gravy. She originally offered a choice of heat in her creations—mild or spicy. Now there's only one way to treat you, and it's spicy.

Looking to come up with something other than hamburgers, Merline experimented in the kitchen, leading to the creation of the Creole stuffed bread. It's a wonderful blend of encased bread baked toasty, not fried, and loaded with beef, pork sausage and jalapeño. So popular are Creole stuffed

breads that a USDA four-thousand-square foot processing plant was built to prepare the breads for wholesale distribution all over the country. She looks forward to the New Orleans Jazz Festival every spring to entice music lovers to her breads. It's bigger than a sandwich; it's a meal.

Her son, Raymond, learned a lot from his mother while attending college. One of his early duties was following Merline's recipes. He was guided to cooking one meat dish a day until he had perfected many to his mother's liking while also mastering a repertoire of hearty delights.

Raymond's secret to cooking is using the right proportion of salt and cayenne pepper and simmering on the stove all morning. Are the dishes Cajun or Creole? "A little of both," Raymond answered. "We cook old-fashioned 'country-style,' and our roux is made with oil and flour."

He was willing to share only one recipe. This amusing recipe for elephant stew is actually posted on the wall—something about simmering for four weeks. Creole Lunch House entertains loyal customers, who need their fill of good rice and gravy on a regular basis. That's why there is a rotating menu, as some eat here a few times a week. It's comfort food with a kick of heat.

GARY'S

104 Lamar Street
Lafayette, LA, 70501

Success has a different meaning to everyone. But to Gary's, tucked in a historic neighborhood called Freetown, success is a lip-smacking plate lunch. When current owner Troy Kling took over Gary's Famous Plate Lunches two years ago, it meant a timeout from his high-level role in retail management. Returning home to Lafayette after spending years in Houston's corporate culture led Troy to a new way of life. Now his days are far simpler, serving flavorful dishes to grateful customers, many of whom he greets by name.

Taking care of hungry folks is what's important to Troy. Many return day after day for a hearty plate lunch at Gary's, opened as J.D. Gary's Grocery Store sixty-five years ago.

In other regions of America, plate lunches have a different name. The southern states enjoy the "meat and three," which is a meat entrée with an assortment of three vegetables or starch sides. The "blue plate special" dates back to early diner days, when a special dish was discounted for hungry

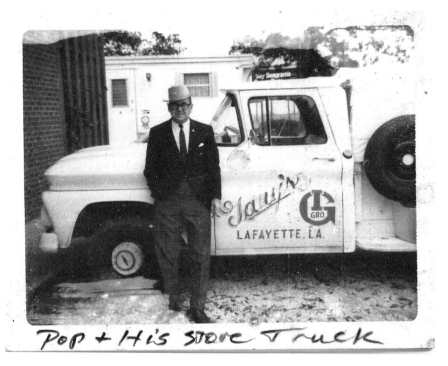

J.D. Gary, who started Gary's Market. *Courtesy of Gary's.*

customers. The plates were actually blue in color; sectioned to accommodate a meat, a starch and a vegetable; and reportedly introduced by the Harvey House restaurants in the late 1800s for rail passengers. The "Hawaiian plate lunch" includes a macaroni salad, white rice and a meat entrée.

The tradition of the portable Cajun plate lunch brings you back to the time-honored technique of an early start in the kitchen, when housewives slow-cooked lunch. This was usually the hardiest meal of the day. By noon, hungry farmers headed to the table, ready to enjoy a heavy meal of juicy meat accompanied by rice and gravy and a side dish, usually beans, with a slice of white bread. Gary's follows through with this, offering two entrées a day and beans every day—red beans, butter beans, black-eyed peas or white beans. During the winter, Ms. Helen, who has been the cook here for twenty-four years, controls the action in the small but organized kitchen, stirring up chicken and sausage gumbo twice a week. "Gary's World-Famous Hamburgers" and hot dogs are also prepared daily.

It's a "no frills" café with concrete floors, which speaks volumes of the popularity of the place. People come here to eat good, well-seasoned dishes.

You can dine inside, outside on the patio, in your car or take it to go. Shelving for grocery items was moved out a few years ago to dedicate the business to preparing the well-liked plate lunches. You learn the routine quickly: choose what's your pleasure from the menu, place your order at the counter, grab a homemade brownie or slice of pecan pie for later and pick up lunch at the window when your name is called, so pay attention. The menu is simple with no changes planned. "We like to be consistent in our cooking by using Gary's original recipes to please our customers," Troy admitted.

Daily offerings include a good roundup of menu items with Cajun rice and gravy. This staple of Cajun cuisine begins with braising the meat in a well-worn black pot and making good use of the pan drippings mixed with peppers, onions and garlic. It's cooked down until you smell a trace of "delicious." Regulars plan their workweek around what's on the menu, stepping in early to have a cup of coffee, read the newspaper, watch a little TV and ease into lunch. Firemen in full gear stop by and park the fire truck across the street. The clientele also includes blue-collar workers, lawyers, policemen and college students coming through.

Gary's is open from 6:00 a.m. to 3:00 p.m., weekdays only. For breakfast, there are a few tasty choices, including boudin. The homemade breakfast sandwiches—a layer of eggs and bacon or sausage patty on toast, prepared fresh—are easy to pick up en route to work.

Wayne Gary, son of founder J.D. Gary, grew up in the business and has an early memory of delivering groceries in a wagon tied to his bike. He did more than deliver groceries through the years, gradually becoming comfortable by playing an active part in cooking for customers. He devised a few handy tools, what he called "Cajun engineering"—like a special yardstick used to measure the size of homemade baked brownies (they should all be cut the same size) and a special funnel for pouring hot sauce into the bottles.

Wayne recalled that in the mid-1980s, competition to the grocery business came to Lafayette by way of supermarkets. He recounted a story about a customer who lived a few blocks from the store. "Mrs. B had a large family, and she called in a long list of groceries she needed to have delivered to her. At the time, we had started to carry less and less groceries and were moving to only preparing plate lunches. Because Mrs. B had been such a loyal customer and we wanted to help her out, I pulled from the shelf everything in stock. And what we didn't have here, I went to the big supermarket down the road to get the rest. We took a truckload to her home, carried the groceries inside and even set them up in the pantry for her," Wayne said with a laugh. "That's the way we believe in treating our customers, more like friends."

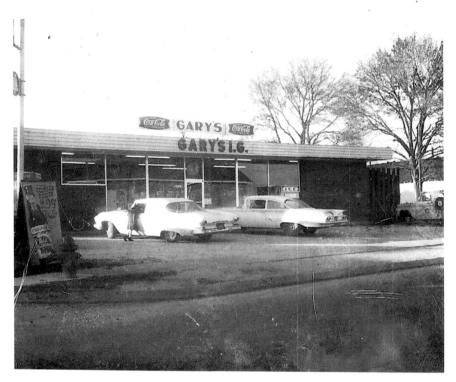

Gary's, serving plate lunches in Lafayette for more than sixty-five years. *Courtesy of Gary's.*

Two years ago, as part of the Gary "extended family," Troy made a life-changing decision to take over the café that he had enjoyed dining in for many years. After a stint working for a local helicopter company, he joined the U.S. Navy as an air crewman. Out of the military, he moved into retail management but became disillusioned with the stress that the long hours placed on his family. And he missed the camaraderie and Cajun culture in southwest Louisiana. Maybe he missed the boudin and crawfish, too!

"I made a decision to keep the legacy that the Gary family started," Troy commented. "Very few changes have been made. We have become so accustomed to our regular customers that when we see one come through the door and he waves to us, we start preparing his dish. Because we know what he likes. It's that kind of friendly, neighborhood atmosphere that reminds me when I lock up in the afternoon that it's been a good day."

ST. JAMES PARISH

Nobile's Restaurant

2082 West Main Street
Lutcher, LA, 70071

Located midway between Baton Rouge and New Orleans, St. James Parish is divided by the Mississippi River. It was settled by a mélange of French, German and Acadian colonists, as well as enslaved Africans, all playing a part in the creation of Louisiana's French-speaking Creole culture. Individually, they contributed diverse cultural traditions to the area, especially in foodways.

Sugar was the same as gold to the plantations in St. James Parish. In 1844, the parish had twenty-eight plantations on the east bank of the Mississippi River and thirty-nine on the west bank. Valcour Aime was one of the first Louisiana planters to produce white sugar by perfecting the process of refining sugar from Louisiana sugar cane. He called St. James Parish his home.

There are claims that this is the only area in the world where perique tobacco is still grown. It gets its distinctive, earthy flavoring from barrel fermentation, a technique Indians taught to the early settlers. In 1820, Pierre "Perique" Chenet was the first to cultivate the tobacco commercially in St. James Parish.

In this growing area, opportunity presented itself when Lawrence (Lorenzo) Nobile, a young Italian immigrant, traveled through Lutcher in 1894. En route to New Orleans by train, he recognized a sense of frenzied activity in the thriving town.

Lutcher was a sawmill community with virgin cypress forests nearby for logging. Thousands of workers were looking for boarding, a place to eat, a watering hole for liquor and sometimes a table for a friendly game of poker. And Mr. Nobile was willing to provide it all. He helped to grow the town by building a two-story building near the railroad in 1895. Over the years, the grand historic building has served as a coffee shop, a barbershop, a doctor's office and, today, a restaurant.

Truly a grande dame of culinary delights, Nobile's Restaurant and Bar has a long history of hospitality. In 1997, the white building with pebble gray accents was reopened by family members, attorney Anthony "Buzz" Nobile and his wife, Winky (whose family owns nearby Hymel's Seafood Restaurant in Convent). It's a great place to raise your glass to toast the cypress loggers who built the town. The romantic setting and soft lighting in the dolled-up dining rooms are a delight for couples, ladies' lunches, tete-a-tete and business meetings as a vignette of yesteryear. On occasion, Buzz moonlights as a bartender at the rich Victorian mahogany bar.

One of the specialties is butterbeans with shrimp served on rice. This is a traditional River Road dish, at one time prepared with river shrimp and fresh butterbeans (lima). A perfect ending to lunch at Nobile's is another regional dish, a dessert called "BaBa." It's a dreamy, three-layered yellow cake with rich custard, topped with a fluffy meringue.

A grande dame of cuisine, Nobile's Restaurant opened in 1895 in Lutcher, an old sawmill town. *Photo by author.*

Some of the busiest times are during the Christmas season, when the parish celebrates "Bonfires Along the Levee," a custom of early French and German settlers. Wigwam-like wooden structures are erected on the levee of the Mississippi River. On Christmas Eve, St. James Parish and adjoining parishes participate in the family-oriented event. It's similar to "tailgating," as groups gather to cook a gumbo as the many bonfires light the way for Papa Noel.

B&C SEAFOOD

2155 Highway 18
Vacherie, LA, 70090

Steeped in history, the community of Vacherie, Louisiana (French for "cattle fields"), blends Acadian, German and Creole cultures. Many plantation homes are still standing in the area, including one named Laura, built in 1805 and representing seven generations of Creole life through the manor house, authentic Creole cottages and slave cabins (twelve buildings are listed on the National Register).

Next door to Laura Plantation is B&C Seafood, where owners Tommy and Geneva Breaux have been in business for thirty years. A perfect place for sampling Louisiana cooking, the roadside restaurant is located along the levee where boats once delivered goods to the plantation homes. There's a casual feel to this 1952 building, originally a drugstore of the Songy family.

Ca c'est bon! House specialties include gumbo, catfish and frogs' legs. Dishes that please your palate are accompanied by fresh-baked French bread. For the adventurous diner, there is a popular delicacy: alligator. Alligator sauce piquante, fried alligator and gator burgers are great to sample though not something you find at too many restaurants. High in protein but low in fat, alligator meat has a mild taste similar to chicken. Ever resourceful, Cajuns continue to look to Mother Nature for a tasty meal to take back to the kitchen table.

Tommy's father once dabbled in alligator hunting, something Tommy continues to do at his camp. The American alligator has been harvested commercially from Louisiana swamps for more than two hundred years, primarily for their skins. Today, the state ranks highest in alligator population in the country, approaching 2 million, with the longest recorded alligator in Louisiana tagged on Marsh Island in 1890 at nineteen feet, two inches and reportedly weighing two thousand pounds.

B&C Seafood, known for gumbo, boiled seafood and gator dishes. Photo by author.

Excitement in the wild attracts guests who are itching to get out there to hunt and fish at the Breaux Camp and are likely be intimidated by the largest reptile in North America. They fish a line and use a hooked pole (a really big hook) to pull in the gator as their prize. Some have the gators stuffed as a trophy, as evident by the appearance of the full-sized, stuffed alligator hanging from the ceiling in B&C's Seafood Market. "The Breauxs are a big family for fishing. We also catch softshell turtles on the line in the lakes and bayous around here. We can take care of cleaning the gators and turtles. And frogging at night is also very popular," Tommy added.

Tommy does the roux cooking (a thickening agent of flour and oil and the first step of preparation for many Cajun dishes). He recognizes that most people don't take the time for cooking this way. "Cajun cooking is smothering food down like gumbo, stews and sauce piquante. You can't rush this kind of treasure," he added.

Boiled seafood is also popular, with trays of blue claw crabs and crawfish. The Breauxs are always willing to demonstrate to newcomers tricks of the trade on eating crabs, where to crack, how to open the "tab" to open the shell, technique for removing the gills and getting down to the chunks of rich white crabmeat. It's worth all of the effort!

On the shelves are something to take on the road, like B&C's own label of pickled beets, salsa, preserves and quail eggs.

ST. JOHN THE BAPTIST PARISH

Jacob's World Famous Andoille and Sausage
505 West Airline Highway
Laplace, LA, 70068

If you're heading upriver along the Mississippi, you'll know when you're near "Jacob's Smokehouse" in LaPlace. Along with the slogan, "Over 85 Years and Still Smokin," there's a promise that the tantalizing aroma from the smokehouse will hit you.

LaPlace, located in St. John the Baptist Parish, was established in the early 1720s by German immigrants, part of the area known as the "German Coast." The town itself was called Bonnet Carré because of the image of a "square bonnet" where the Mississippi River turns in a right angle. Although it remained under the French regime until 1768, the French and German cultures intermingled. It was during this time that the Acadians began arriving after expulsion from Nova Scotia. Both the Cajun and German cultures are credited with smoking andouille, which is Jacob's best-selling meat.

One of the early German immigrants to Laplace was Nelson Jacob. He brought with him the German tradition of making andouille at community pig slaughters. During these boucheries, families shared pigs and meat products. Nelson specialized in andouille, a well-seasoned, heavily smoked sausage of coarser chunks. It's an essential flavor to add in gumbo and jambalaya, along with other popular Cajun dishes.

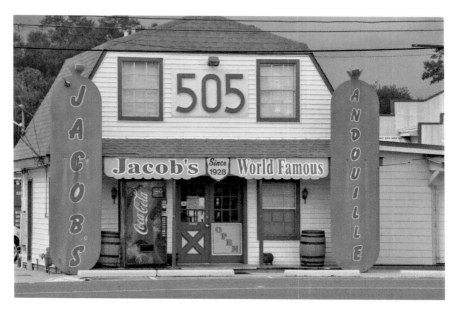

Specialties of andouille and other smoked meats at Jacob's in Laplace. *Photo by author.*

During World War I, Nelson was stationed in France, where he met Camille Charnet from Vichy. He returned to Louisiana with Camille as his bride, with her mother and sister following the young couple soon after. The ladies became refined seamstresses, sewing hats and clothing, while Nelson worked at a sugar refinery.

When Nelson Jacob became a merchant, setting up shop in 1928, he was the first to make and sell andouille commercially in the area. The main crowd pleaser was andouille, although the shop also had wares of homemade hats, clothing and essential goods. Nelson and Camille were known as "Bragger" and "Mam-Bragger." Their youngest son, Henry "Diddy," followed in their footsteps in the business.

The Jacobs expanded by purchasing the old Maurin's Home Staple Store building in Laplace in 1947, adding a post office, a bar and barbershop to accommodate the community.

In 1972, Louisiana governor Edwin Edwards declared LaPlace, Louisiana, "Andouille Capital of the World." An annual October festival features a cook-off with competing chefs vying for the best gumbo, jambalaya, or miscellaneous. But it all starts with the andouille.

The technique of smoking andouille is similar to the early days, as the same Jacob smokehouses from the 1920s are used. Chubby links of well-

marbled andouille are prepared and hung in the smokehouses. Once a fire is started and smoldered to the right temperature using pecan wood, andouille is smoked for eight hours. Behind the scenes are also sizzling racks of turkey legs and chicken breasts.

When Mam-Bragger died in 1978 at age seventy-eight, her granddaughter, Mary Ann (Diddy's daughter), took a more active role. With the construction of a new "barn-shaped" building that same year, more smokehouses were added. When Mary Ann retired in 1994, her son, Aaron Lions (fourth generation), took over, armed with his great-grandfather's recipe.

Although you have customers streaming in year-round, when the first cold front of fall comes around, the doors are swinging at Jacob's Smokehouse. It's "gumbo weather," a recognizable time to stock up on the popular meats that find their way into standard Cajun fare. Other available products include beef jerky, seasoning mix, smoked chicken and turkey.

ST. LANDRY PARISH

CANNATELLA'S

421 Landrum Street
Melville, LA, 71353

At one time there was a grocery store open for business on every corner in Melville. Located on the main thoroughfare between Shreveport and New Orleans, the town was booming. Cars lined up to ride the ferry across the Atchafalaya River, although it no longer runs.

When the Great Flood of 1927 came through and the levee broke, the community was flooded with water covering the Melville streets for two months. The flood was described by then U.S. secretary of commerce Herbert Hoover as "the greatest peace-time calamity in the history of the country." Another factor that influenced Melville's destiny was when Huey P. Long came around for some good ole' boy politicking, shouting atop a tomato crate about his plans as governor to the crowd. He felt that he had been slighted and had not been truly supported. So, in choosing a route to run Highway 190, east–west through the state, the Kingfish saw that Melville was bypassed.

Although the Cannatella family lived through the flood and the hardship of the Great Depression, they also envisioned opportunity. The forefather of the family, Joe, emigrated from Palermo, Sicily. He gained experience in running a store along Bayou Rouge, a settlement of Italian families in 1901.

Staples like sugar, flour, beans and coffee were shipped by boat, with early morning delivery along the levee.

Joe and Charles Cannatella (father and son) bought property in downtown Melville in 1923 to set up a general store. Every necessity to run a household as well as a farm was available—saddles, halters, clothing and shoes, fabric to sew fine dresses and staple goods. In the early days, customers never walked behind the counter. Instead, the customer indicated which items he wanted, and the storekeeper gathered the items for him. The Cannatella family lived next door to the store for convenience, as the store was their life.

On the morning when the levee broke during the Flood of 1927, Charles sent his family to Baton Rouge by train for safety. He and his father remained at the store throughout this distressing time to guard the house and store. When the high waters receded, the family was reunited in Melville.

Over the past ninety years, other generations of the Cannatella family have taken charge. Pete and brother Joe ran the business, and today Pete's sons, Grant and Brian, who are the fourth generation, run Chas. Cannatella & Sons. In 2001, when the brothers took over from their father, they upgraded the coolers, adding a kitchen to provide hot meals. The deli kitchen provides a daily plate lunch Monday through Friday. Seafood such as shrimp and crab stew is cooked on Fridays, with barbecue on

Cannatella Store in Melville began in 1923. *Photo by author.*

Sunday. Old-country dishes such as Italian lasagna and eggplant casserole are baked on a regular basis.

Today, the store continues to offer essentials such as nails, plumbing supplies, fishing poles, toys, barbecue supplies, household goods, cooking pots and a full stock of groceries.

Cannatella's specializes in fresh Italian sausage with a touch of fennel seed for extra taste. Muffulettas big enough to feed a family of four are homemade. Round loaves, about ten inches in diameter, are cut in quarters and baked in the store. The muffuletta sandwich was created in New Orleans in the early 1900s. Layers of ham, Genoa salami and mortadella bologna are stacked on slices of provolone cheese. An olive salad mix of olives, peppers and garlic tops the meat.

The original Cannatella's general store is a neat old place with concrete floors and tin ceilings; it's attached to the more modern supermarket. At the rear of the old general store are bins and shelves filled with nails, PVC pipes and a variety of hardware supplies. It's a heartwarming mix of the old and the new through a heritage of four generations of Cannatellas with a passion to welcome customers as friends.

Budden's Store

165 Railroad Avenue
Palmetto, LA, 71358

The setting is not too far removed from the day in 1934 when Budden's Store opened its doors as a trade center for the surrounding agricultural area during the Great Depression. It continues to offer a little bit of everything: housewares, toy guns, galoshes and more.

Once the site of a cotton gin and now a fertilizer plant, Palmetto, a one-stoplight town, has a population of two hundred. There's a railroad track in front of this charmingly quaint, wood-framed structure that has preserved the feel of an old general store. The owner of nearby Holly Grove Plantation named the village Palmetto for the fan-leaved plant prevalent in the area.

Allen "Chuck" Budden and his wife, Rita Boudreaux, built the store with a house once attached. During the Great Flood of 1927, Allen worked for the Red Cross. According to the original ledger, five dollars is what he brought in on his first day in business.

Budden's Old General Store opened in 1934 in Palmetto. *Photo by author.*

It's a living museum blessed with an atmosphere that conjures up childhood memories of penny candy and other simple pleasures. It stocks lemonade, coffee makers, gumbo spoons and a prized sausage stuffing machine. If Budden's doesn't have it, you don't need it! Of course, tourists love to stop by to see what are now antiques, like the old lantern on the shelf. The oak flooring is sturdy and doesn't give way as school kids come through for field trips to be awed by a part of Americana in their own backyard. The original pressed-tin ceiling is far above the shelves. When a customer comes by needing a new spark plug, the Buddens point him in the right direction. Light bulbs, bicycle supplies, cowbells, ice cream and snacks are handy.

Hunting supplies are a big part of the business, as St. Landry Parish is popular during deer hunting season. There's a deli set up in the back of the store (this section was once the attached living quarters) where sandwiches are made and links of boudin heated.

At one time, Palmetto, which celebrated its centennial in 1988, had six grocery stores, two sawmills, a movie theater, a barbershop, a boardinghouse and a few bars and pool halls. A rail passenger service once guided visitors in and out of Palmetto. To ride the train, you waved a white hanky along the route to signal to the engineer that you wanted to be picked up. In Palmetto, sidewalks were wooden. The road was dirt and gravel until paving came

through in the 1950s. Next to the store was the moss gin. Moss was picked from the trees and sold to the gin, where it was cleaned and baled for use in car seats, mattresses and upholstery.

Guyton Budden, son of Allen, was the youngest child—or "caboose," as he calls himself. He moved away from Palmetto to attend college. Both of his parents lived into their nineties, and his father is remembered as a strong man, continuing to unload supplies from the grocery truck while still in his eighties.

But Guyton did indeed return to Palmetto "scratching and fighting" to take over the store. "Now I will never leave," he said. "I can't imagine being anywhere else than in the legacy created from my parents' hard work. People really enjoy taking a trip here to take a look at an old-time country store."

There are many items of sentimental value in the store, like an old wooden ballot box. Old-timers remember the day when Allen Budden ran for public office. It was a race he lost. But to compensate for this, the authorities gave him the ballot box, which Guyton still proudly displays.

The Little Big Cup

149 Fuselier Street
Arnaudville, LA, 70512

Russell's Food Center

114 Main Street
Arnaudville, LA, 70512

In the portrayal of a small town, the painter's canvas may include scenes of uneven sidewalks shaded by oak trees, neighbors working in home gardens and folks watching the orange sunset as it fades into the bayou. The community of Arnaudville, Louisiana, population 1,400, is a slice of Americana with a French accent.

Arnaudville was originally known as La Jonction, French for "the Junction," as the spot where two meandering bayous met—Bayou Teche and Bayou Fuselier—becoming a rich farming center of cotton, yams and sugar. Traveling is on a picturesque drive through winding roads along the bayou to what has become a thriving art and music haven. The town also enjoys "French table" socials in which the locals and visitors speak French.

What began as the Coles General Store in 1934 has launched two businesses following a family heritage of serving customers. George Clifton Coles and his wife, Nora Castille Coles, migrated from the oil fields of Arkansas, seeking steady work following the Great Depression. The Coles learned of a building for sale in downtown Arnaudville. Wouldn't it be a fitting location for a dry goods business? They didn't hesitate to hand over $36,000 for the thirty- by forty-foot wooden structure, with additional funds borrowed from family members to stock the store.

Staples of sugar, rice and flour were sold and weighed by the pound and crackers by the piece. Tasty bologna sandwiches were prepared to feed folks. George, his wife and their two children had snug quarters, living in the back of the store in makeshift accommodations. Curtains were hung to divide the open area to fashion rooms. Mrs. Coles did double duty by tending to customers in front while also cooking meals for her children in the back. Ever mindful of serving customers, the store enjoyed a slow and steady growth.

In 1950, George and Nora's son, J.R. Coles (Joseph Richard), and his wife, Genevieve Willis Coles, took over the store from his parents. Through remodeling and enlarging of the building, the store served the downtown area for the next thirty-eight years.

When J.R. retired in 1978, he sold the grocery store to his oldest daughter, Cynthia, and her husband, Russell Robin, both of whom had worked in the store for many years. With their five children beside them, the Robins carried on until they tore down the old wooden structure to accommodate a larger, more modern structure renamed Russell's Food Center.

While Russell had worked as a butcher in the family store for many years, he had also gained prior experience in large supermarket chains in Lafayette before returning to Arnaudville. He set in place the old Cajun-French style of meat cutting, seasoning and marinating. In 1987, daughter Melanie Robin, who worked alongside her father, took over the responsibility as co-owner. She directed the store into the next century with her brother, Russell "Francis" Robin Jr., who joined her in 2008. Melanie's daughter Magen Olivier Turner (fifth generation) has also joined the business, which also includes catering services.

Melanie related that she and her siblings grew up in the store. She started working at Russell's during high school, first as cashier. She enjoyed the early days, when she and her mother worked long hours stocking shelves, Melanie the cereal row and her mother health and beauty aid. "We kept busy unpacking boxes but visited with customers as we worked. It was a lot of fun," she said.

Get your senses in gear for a trip to Russell's. The chicken and sausage jambalaya alone is worth a visit to this country store. The daily plate lunches will get you in, but there's much more to this treasury of Cajun delights—deboned, seasoned and stuffed turkey rolls, fresh chicken sausage, smothered steak, brisket, seafood specialties, jalapeño sausage bread and bread pudding. Just about everything you have the "envie" or desire for, whether sweet or salty, is made to order—fettuccini, meatloaf, side dishes like creamy mac and cheese, cornbread dressing, fried okra and a variety of casseroles. The bakery entices you with pretty cakes—red velvet and carrot cake, Dobash and more. If you love the aroma of bread baking, there are dinner rolls and French bread.

When Melanie's brother Kevin Robin returned to Arnaudville from New York in 2011, he was bursting with ideas. His hometown seemed to have just about everything, though what was missing was a coffee shop. He and partner Sanjay Maharaj from Trinidad transformed a small building, formerly an auto parts shop, in the quaint downtown area across from Russell's. Refinishing the wood floors and adding color to the walls perked up the shop, which they named the Little Big Cup, as bright and airy, with a "living room" atmosphere. Homemade desserts and the coffee beans were

Little Big Cup in French-speaking Arnaudville. *Photo by author.*

only the beginning. Through word-of-mouth acclaim of tasty tidbits, the cozy shop mushroomed into something more as comfort foods like soups, gumbo and a seafood bourbon salad were prepared. An addition, the Bayou Warehouse, complete with a wooden deck overlooking the Bayou Fuselier, provides more dining space outdoors.

Weekends are for a generous boucherie-style brunch of mouthwatering dishes such as ribs, boudin, giant homemade biscuits and cinnamon rolls, grits, pork roast and crème brûlée French toast. Friday and Saturday nights are for the "Surf and Turf" buffet, with praline chicken, catfish court-bouillon, broiled "catch of the day," braised pork shanks and redfish dishes. Homemade desserts include cappuccino mousse, homemade ice cream and Italian cream cake.

Ever mindful of the humble beginnings of the family business, the Robins continue to add sparkle to their hometown where generations have earned their living at the stove. A one-of-a-kind vintage advertising sign of Evangeline Maid Bread displayed as artwork at the Little Big Cup serves as a reminder of the old Coles store, where it once hung on the screen doors.

Steamboat Warehouse

525 North Main Street
Washington, LA, 70589

It's probably one of the most memorable dining experiences you will ever have. There's a lot of history seeping through the Steamboat Warehouse Restaurant, situated in Washington, the third-oldest settlement in Louisiana. Established as a French trading post in 1720 by early French and Acadian settlers, the community was once called Church's Landing as the site of the first Catholic church in St. Landry Parish.

As a leading center of commerce in the 1800s, Washington ruled the waters with claims that it was the largest inland port between New Orleans and St. Louis, Missouri. It hosted a cotton gin, a cottonseed oil mill, a distinguished opera house, a shop specializing in making buggies, cooper shops for making barrels and a stagecoach line station. "Floating stores" of merchandise used Washington as a takeoff point. These stores on boats carried medicines, spices and necessities, with merchants stopping at every port to sell their wares.

Workers scurried to load and unload cargo from steamboats, barges and wagons, keeping the dockside alive with activities of trade. Cotton and other crops from nearby plantations were delivered to Washington on flatboats, stored in warehouses that lined the bayou and readied for shipment to New Orleans. Riches of wine, whiskey, cigars, coffee beans, silk, champagne, fine china and exotic food supplies were imported from Europe and Cuba.

The town continues to reflect a passion for its history. Listed on the National Registry of Historic Places since 1978, 80 percent of Washington's buildings have been identified as being of historic or architectural significance. One of the factors affecting major change in this steamboat town was the arrival of the railroad, causing river traffic to diminish. The Civil War also changed the dynamics of Washington's role as a leading U.S. inland port. With Union occupation, engineers cut off waterways, limiting transportation to and from New Orleans. The last steamboat to depart from Washington in 1900 was the *Warren*, a 180.0-foot-long and 37.6-foot-wide steamboat that once carried up to 3,200 bales of cotton.

The Steamboat Warehouse, dating to 1823, is the only survivor of a string of seven warehouses along the Bayou Courtableau. Truly a relic, the atmosphere suggests haunting whispers of the sound of a steamboat from years past. A woodsy interior of cypress and double-brick walls is subtly lit with wagon wheel fixtures. Block and tackle once used for lifting and weighing hang on huge, hand-hewn cypress beams from the ceilings. A pirogue (Cajun canoe) carved from a log is displayed, adding to the charm. The setting of the bar is entertaining—a comfortable spot to quench your thirst with collectible liquor decanters lined up on the shelves. As politics has always been a "hot" topic in Louisiana, the bar has photos and posters of former Louisiana governors Huey P. Long and O.K. Allen. A preserved anchor found in the Warehouse during renovation in the 1970s dangles in the bar. Appropriately, there's a model of a steamboat and a display of original square nails forged by local blacksmiths that were used to construct the Warehouse.

During the 1970s, the Steamboat Warehouse was converted from a dusty warehouse into a restaurant. A commercial kitchen and bar were built in, and a concrete floor was added, as the structure had only dirt flooring. Patches were applied to the brickwork, enhancing the look of the place. The outdoor patio offers a picturesque view of the bayou crossed by a steel stringer bridge.

Steaks and seafood are featured on the menu by owner/chef Jason Huguet, who began working at the Steamboat Warehouse at age eighteen,

Steamboat Warehouse in Washington, Louisiana's third oldest settlement. *Photo by author.*

right after graduating from high school in nearby Opelousas. He never foresaw his future as staying on for twenty years, leading to ownership in 2006. The climb up the ladder of his success started at the bottom as a busboy and dishwasher. As his work ethics, creativity and reliability flourished, he progressed into the kitchen and then into management. In recognizing Jason's gift, the restaurant owner at the time, Frankie Elder, offered to sponsor Jason at culinary school. He graduated cum laude from the Chef John Folse Culinary Institute at Nicholls State University in Thibodaux, Louisiana, with a Bachelor of Science degree in culinary arts. He especially enjoyed learning directly from Louisiana native and leading authority on Louisiana cuisine, John Folse. Undergoing an internship under Chef Paul Prudhomme of K-Paul's Louisiana Kitchen in New Orleans, Jason gained valuable, hands-on experience, leading him to win many awards as "Best Chef."

Although willing to experiment with dishes, Jason sticks to his Cajun and Creole roots with most dishes. But there are always exceptions when he comes across something interesting to play around with. A new dessert is *panna cotta*, Italian for "cooked cream." Jason points out that there are only four ingredients to create this simple, traditional, pudding-like Italian treat, which he serves in ramekins and tops with a blackberry glaze.

"It's a challenge to come up with something new to spark the interest of customers, but that's the fun of having daily specials," Jason said. He stays open-minded about creating new recipes, incorporating a variety of fresh fish on the menu, some that are not available within a one-hundred-mile radius. He retains a hands-on approach in the kitchen and garden, selecting native herbs from Louisiana's backyard to his dishes. One of the old favorites is appropriately named for a waterfront eatery: the Steamboat Gang Plank, an eight-ounce rib-eye topped with crawfish étouffée. "The reward comes from selecting the right combination of spices and herbs to keep my people happy," Jason concluded.

ST. MARTIN PARISH

CAFÉ DES AMIS

140 East Bridge Street
Breaux Bridge, LA, 70517

A Native American legend claims that an enormous snake lived in the Louisiana swamps many moons ago. So long was the snake that it was measured in miles rather than feet. When the warriors of the Chitimacha tribe fought against the giant snake and conquered it, so mightily did the snake thrash about that the area where it lay was deepened and a bayou formed. The meandering Bayou Teche, a 125-mile waterway in southwest Louisiana, served as an important waterway for the Acadians as they traveled through Cajun Country. This bayou "snakes" through the countryside in towns such as Breaux Bridge.

The Breaux family is credited with developing the town, founded in 1829. As the largest landowner, Firmin Breaux built a footbridge across the bayou to provide easy passage for neighbors on both sides. His daughter-in-law, Scholastique Picou Breaux, continued to grow the town.

The town hosted its centennial celebration in 1959, complete with street parades, musical entertainment and the crowning of a queen. That same year, the Louisiana legislature proclaimed the town the "Crawfish Capital of the World." Breaux Bridge continues to host the Crawfish Festival every spring, enjoying a crawfish-eating contest, crawfish races (the crustacean

Breaux Bridge, home of the Crawfish Festival. *Photo by author.*

races backward), French music, a demonstration of the Cajun card game called bourée, a crawfish étouffée cook-off and serving up of crawfish cooked every way imaginable. Breaux Bridge retains its small-town charm and French heritage.

Wooden caskets were once constructed in the old Pellerin building, a few blocks from the Bayou Teche in downtown Breaux Bridge. Rumors of upstairs hauntings abound. Now there is a much livelier scene, especially on Saturday mornings.

At Café des Amis, the zydeco music cranks up at 8:00 a.m., and the place is jam-packed. Arms are swinging and feet are stomping on the old wooden floor as the singer wails "Zydeco Cha Cha." Dancers of all ages and nationalities take turns twisting to the fast-paced music during the Zydeco Breakfast.

The Pellerin building, which houses Café des Amis, was built in 1890 as a one-story structure. After a fire caused damage, it was rebuilt in brick and a second story was added. A hand-operated Otis elevator was used to move the stacks of caskets from upstairs to downstairs. The elevator, the first of its kind in this once rural area, has been refurbished and placed near the

Pellerin Building, which houses Café des Amis in downtown Breaux Bridge. *Photo by author.*

entrance of the restaurant to serve as a hostess station. Another focal point is the colorful artwork by local artists on the brick walls. Pressed-tin squares adorn the ceiling.

When Dickie Breaux, a former member of the Louisiana House of Representatives, purchased the building in 1992, Café des Amis was used as an art gallery. The paintings remained, complemented with offerings of coffee and bakery items. Gradually, as the groups of customers stopping by grew, mostly by word of mouth, a few more dishes were added to the menu.

The restaurant's unique 1930s-style black walnut and marble stand-up bar comes from what was once the Evangeline Hotel in downtown Lafayette. Dickie is experienced in overseeing restoration projects throughout Louisiana. He is a direct descendant of Firmin Breaux, whose family founded Breaux Bridge. Café des Amis is an easy walk to flea market finds, ladies' clothing shops, gift shops, old churches and jewelry stores.

The secret to the café's success is no secret. It's the whimsical atmosphere, energetic music and delicious food that make it so popular. Among the breakfast dishes are couche-couche. This traditional Cajun cereal, similar to cornmeal mush, is served with milk, syrup and sugar. And how does a pig's

ear sound as another breakfast delight? The restaurant offers a variation of oreille de cochon, twisted beignet dough shaped like a pig's ear, stuffed with grilled boudin and sprinkled with powdered sugar. Specialties at dinner include barbecue shrimp with heads-on shrimp served in a buttery, garlicky sauce; turtle soup; and roasted duck with pepper jelly glaze. For a sweet treat, the white chocolate bread pudding pleases all. Bread pudding is a creamy Louisiana dessert that makes sense. Leftover bread is cut up, soaked in a beaten mixture of eggs, milk, sugar and vanilla and then baked.

One of the most exciting times at Café des Amis was the build-up to Super Bowl 2003, when native son and quarterback Jake Delhomme of the Carolina Panthers led his team. Reporters looked forward to visiting Breaux Bridge because of its French influence and great food. They found relaxation in the small-town charm and humor in simple things, like listening to the local TV newscast in French and flipping through the local phone directory, which still carries nicknames like Pope, T-Boy and Nook.

Café des Amis has a loyal following of fans from all over the world who enjoy the ambiance similar to a café in France. The lineup for Zydeco Breakfast gets longer the closer you get to Mardi Gras. If you come early, you can sit in the window to watch the people go by as you sip your café au lait.

POCHÉ'S MARKET

3015-A Main Highway
Breaux Bridge, LA, 70517

In the area is a neighborhood called Poché Bridge, which also lies along the muddy Bayou Teche. In the early 1940s, the Poché family owned a cotton gin and meat market where Joseph Poché Sr. slaughtered pigs and held boucheries. A boucherie stems from a tradition of slaughtering a pig and cooking virtually every part (everything but the "squeal") to prepare boudin, sausage, hogshead cheese and enough salt meat to feed a family.

Boudin, as noted, is a combination of chopped-up boneless pork meat and liver, seasoning and onions, mixed with cooked rice and stuffed into a casing. It looks like a sausage, but the addition of rice as a filler makes it a whole new dish. The meat is already cooked when you stuff it. Easy to handle, boudin is very popular for breakfast on the go. Poché's has not

Famous for its boudin, andouille and plate lunches, Poché's is located along the Bayou Teche. *Photo by author.*

measured how many links it has made since the early days, but its signature T-shirt says it all: "Happiness is a Hot Piece of Boudin."

Fans of those crunchy tidbits of pork skin and fat called cracklings saunter out with paper bags full of the Cajun snack to munch on. Once the cracklings are fried in big open kettles, there's a generous sprinkling of cayenne pepper added on.

In 1962, one of Joseph's sons, Lug Poché, followed the family tradition of running the neighborhood meat market, adding barbecue plate lunches on the weekend. A few years later, a dining room was opened to accommodate customers. His son Floyd (third-generation owner) began working in Poché's Market while in seventh grade, along with his siblings.

In the early 1980s, Floyd took over the family business, opening shop seven days a week. That meant daily plate lunches to cook, a few more shelves of

groceries to stock and the expansion of the meat market. Some shopkeepers are born to it, and Floyd realized the importance of offering a variety of dishes that are consistently appealing. The menu has not changed much over the years, staying true to the Poché recipes. There is a Cajun saying that plowing into Poché's seven-course meal means enjoying a link of boudin and a six-pack of cold beer to fill up on.

You'll find hearty country cooking at Poché's. The showcase includes specialties like pork backbone stew, stuffed pork chops, smothered rabbit, fried chicken and pork roast. Add to it a hefty side dish of rice dressing, also called dirty rice. It's simply rice cooked along with bits of chicken liver and giblets, peppers and onions. And then there are the seafood offerings. Beginning in 1985, fried catfish, fried shrimp and crawfish étouffée were added. The Cajun comfort dish of chicken and sausage gumbo is also served during the winter months.

Although Poché's caters to the community at large, hunters in camo en route to the camp during deer season stop by. Visitors to Breaux Bridge's Crawfish Festival and Lafayette's Mardi Gras are also attracted to this destination spot. The customer base has included two Louisiana governors as well as celebrities who have frequented the area during movie shoots.

One factor that helped Poché's Market grow was the addition of a USDA-inspected processing plant in 1993. That allowed Floyd to share his Cajun products all over the country, including alligator sausage, chicken and sausage gumbo, crawfish boudin and many other items. In high demand is the andouille (coarse, ground pork stuffed in beef casing and heavily smoked) and tasso (smoked pork meat). Poché's takes a great dish one step further by stuffing chickens with crawfish, sausage or spinach, combining great flavors.

Floyd Poché continues to man the skillet in the kitchen. He learned about Cajun cooking from his father. "It's more than just adding red pepper. It's about slow-cooking and simmering," Floyd noted. "It may be simple, but it's good!"

PAT'S FISHERMAN'S WHARF RESTAURANT

1008 Henderson Levee Road
Henderson, LA, 70517

L'ecrevisse (the crawfish) was once considered "bait food," something consumers outside Louisiana considered unappetizing. Today, as one of the

most popular icons of our Bayou State, crawfish is prepared as a gourmet entrée in a variety of ways throughout the world. It's not a pretty mudbug, but early on, St. Martin Parish was the main locale where crawfish has been harvested and introduced to restaurants as a delicacy. Pat's Fisherman's Wharf Restaurant in Henderson was one of the first in Acadiana to dish up the tasty crustacean.

Pat's has long served as a destination spot for customers who make the pilgrimage to their favorite restaurant by crossing the swamps of the Atchafalaya Basin. Atchafalaya (pronounced "uh-chaf-uh-lie-ya") is Choctaw for "long river." As the largest river swamp in America—with more than 1 million acres of bottomland swamp, bayous and backwater lakes—the Atchafalaya is the main source of deep-water crawfish. Local farmers cultivate crawfish ponds, also adding to the region's supply.

Owner Pat Huval was six months old when his father, Tom, a fisherman by trade, died in Pelba, one of the communities washed away during the Flood of 1927. Pat was the youngest of five boys. Working the fields in the area known as Grand Anse to support her family, Pat's mother, Noelle Berard Huval, planted a home garden to feed her family and killed hogs for family boucheries. Pat couldn't keep up with his brothers picking cotton, so he was relegated to kitchen duty. His time in the kitchen turned out to be a blessing, as he learned the country art of cooking from his mother.

In 1948, Pat opened a grocery store in Grand Anse near his mother's, selling live crawfish at a penny a pound and a sack for forty cents. An opportunity arose a few years later from Henry Guidry, who leased out his dance hall for Pat to serve beer and homemade hamburgers to his patrons.

Pat's has progressed to its current site along Bayou Amy, where you really can see catfish jumping and gators swimming if you stroll along the boardwalk of the roomy restaurant. Besides the beautiful sunsets along the river, inside are eye-catching murals of swamp scenes. Adding to the atmosphere is a replica of an anchor boat, which is placed at the entrance leading to the bar.

With only a third-grade education, Pat has accomplished quite a bit in his eighty-six years. His generation made many sacrifices, and children often had to discontinue their education to help on the farm. But that did not stop Pat, ever enterprising, from aspiring to greater achievements. He developed an ambitious plan for putting the fishing community of Henderson on the map. As first mayor of the town, he saw it incorporated in 1971 and served as mayor for nearly twenty years.

Pat's Waterfront Restaurant, one of the first Cajun Country restaurants to serve crawfish. *Photo by author.*

Pat's Waterfront Restaurant is famous for its seafood platter, a smorgasbord of seafood delights. It's served with a cup of seafood gumbo and ample samplings of fried shrimp, oysters, frogs' legs, catfish, stuffed crab and shrimp, hush puppies and seafood dressing. Punched-up crawfish dishes of every kind are also featured on the menu, many from recipes of Pat's mother.

The adjoining Atchafalaya Club was added years ago as a club and reception hall. Live music, alternating between zydeco, Cajun and swamp pop, is featured every weekend. Kids are welcomed, too, because of the restaurant atmosphere in this ten-thousand-square-foot club, popular for reunions and other special functions. Pat produces "Pat's Roux Mix," where roux is produced in a huge black kettle roux pot that he designed with stainless steel blades that stir continuously. A crawfish processing plant produces bags of crawfish tails ready for cooking, and a twenty-eight-room motel is adjacent to the restaurant.

Pat's children Harvey Huval and Cynthia Domingue manage the Henderson location. Son Jude Huval, a graduate of the LA Culinary

Institute, recently opened a Pat's in Baton Rouge. Daughter Nancy and her husband, Ricky Perioux, run a location in Lake Charles.

The saying stays the same through the years: "The catfish is so fresh it slept in the bayou."

Bayou Cabins
100 West Mills Avenue (Highway 94)
Breaux Bridge, LA, 70517

It's a quirky little village that started off as a folksy café. Twenty-seven years ago, Lisa and Rocky Sonnier served Cajun favorites of boudin, cracklings and hogshead cheese, as well as barbecue on Sundays. Among other experiences, Lisa had worked at a hamburger stand during high school. Rocky has won first place in a cook-off at a local Crackling Festival on more than one occasion, earning him the local title of "Crackling King" for his unique way of frying the crunchy, well-seasoned pork rinds. Admittedly, it took a leap of faith to start off their business, looking to their Cajun culture for ideas. A reclaimed cypress house, circa 1869, was restored and converted to a café. Decorated with Cajun music memorabilia, a Hadacol advertising sign, an autographed photo of country music legend Hank Williams Jr. (who was a guest) and variety of paintings of Cajun scenes, the café exudes a country charm.

Over the years, the Sonniers capitalized on their location off the beaten path. In a shady area along Bayou Teche, Bayou Cabins is a few blocks from the quaint downtown of Breaux Bridge. When the opportunity of acquiring another old house came up, the Sonniers moved it near the café, and a Cajun village of bed-and-breakfast cabins was launched.

"Come Sleep on the Bayou," as the Sonniers now oversee an eclectic mix of fourteen cabins. Many of these old cottages are of cypress wood, topped with a tin roof. Set up to serve as a hideaway, they were moved from various locations from within St. Martin Parish, restored to their former glory and furnished with antiques and interesting bric-a-brac. The oldest dates back to 1848; the walls are built in the old Cajun way of bousillage. If you want to be "nothing but a hound dog," there's an "Elvis" Cabin, decorated in '50s style. A Victorian Cabin has a claw-foot tub for soaking. Some are equipped with kitchens or two bedrooms, and some have rockers on the front porch.

Bayou Cabins serves its guests crackling in a quirky atmosphere of restored cabins. *Photo by author.*

A rustic cabin has 1949 newspaper serving as the wallpaper. It's a neat kind of place where you can see fish jumping in the bayou from the cabins with back porches.

The Cajun hospitality of the Sonniers, who both speak French, includes a repertoire of breakfast dishes. There's beignets shaped like crawfish claws, boudin, crackling, sausage and hogshead cheese. The specialty boudin features an appetizing blending of shrimp, crawfish and crabmeat.

Aside from the serenity, there are activities for venturing out. Nearby are antique shops to visit and fun spots to tap your feet to the *chank-a-chank* of Cajun music. Located within a short drive is Lake Martin, a wildlife preserve that draws outdoor lovers for bird watching, fishing, canoeing and swamp tours.

There's a throwback to a sci-fi flick with a display of a giant crawfish structure on Bayou Cabin's grounds. It has been featured for many years during Breaux Bridge's May Crawfish Festival parade.

The Sonniers occasionally host a cochon de lait (pig roast), crawfish boil or gumbo at the request of their guests. It's a popular retreat for reunions,

Giant crawfish featured in Breaux Bridge's Crawfish Festival parade. *Photo by author.*

although the majority of their visitors are from outside the United States. A world map posted in the café with pins marks the origins of their guests. "A stranger is merely a friend we have not yet met" is the motto of this cozy eatery, as many travelers stop by for some peace and quiet, collecting memories along the way.

TERREBONNE PARISH

CHESTER'S CYPRESS INN
1995 Highway 20
Donner, LA, 70352

You may expect to see June Cleaver coming out of the kitchen serving the renowned Chester's fried chicken on paper plates.

Although Chester's was built in the 1930s, a few efforts at remodeling have kept the multiple dining rooms stuck in the '50s. The décor includes framed chicken drawings displayed on buttercup yellow-and-green patterned wallpaper. Perched along the bar is an eclectic collection of ceramic and wooden chickens. It's housed in a wood-framed building with green siding and a covered overhang that invites you to park right up to the front steps. It sports a friendly atmosphere where generations before you have carried in their babies and kids for home cooking. And the beer is cold.

Fried chicken, always fresh, crispy and hot, is the main attraction. Drumsticks, thighs, breasts, even gizzards and livers (they once also served chicken necks) are piled high on platters. Side dishes include endless circles of crispy onion rings and hand-cut French fries. Rounding out the menu are frogs' legs, catfish (added in the '70s) and shrimp (added in the '90s).

Donna Boudreaux, granddaughter of the original owner, Chester Boudreaux, is manager. She also works as a guidance counselor in a nearby high school. Her earliest memory of Chester's was counting and dropping

Chester's is renowned for its fried chicken. *Photo by author.*

pennies in the cash register. "I've never left the area," she noted. "My major in college was home ec., so I enjoyed training kids on how to set a table, bus a table, wait on a table—everything involved in working in a restaurant."

Chester's is open four days a week—Thursday, Friday and Saturday for dinner and Sunday for lunch and dinner. It's off the beaten path though well known in the parish; it's right on Highway 20, once the main drag for traveling to New Orleans.

It started out as a grocery store in Donner, a sawmill town. Over the years, the Boudreaux family converted the store into a dance hall. Second-generation owners Chester Jr. and Hazel were handy in the kitchen, providing their patrons a bite to eat. The area flourished during World War II because of soldiers stationed in the U.S. Coast Guard in Houma and Morgan City. There was no fancy menu, although the specialties were chicken dishes like chicken spaghetti and chicken rice and gravy. This repertoire did not originally include fried chicken until a state trooper and family friend helped out by lending his batter recipe to the Boudreaux family to cook southern fried chicken.

Once the war ended, the dance hall was converted into a restaurant. Perfecting crispy, "home cooked like Mama's" fried chicken was important.

The degree of heat is made to order, all named in honor of Chester's friends. If you like it spicy, you order the "Montet," named for Numa Montet of Thibodaux, an attorney/politician/first-class chef. He liked his chicken spicy with a generous sprinkling of cayenne pepper. "Frank" style, named for family friend Frank Cora of Napoleonville, means cooked with salt only and no batter.

They are used to accommodating their customers by using the freshest ingredients. There was once a shed behind the restaurant where the family members killed and dressed fresh chickens.

"In the old days, when an order was ready, the cook jingled a brass bell so everyone could hear. We've modernized a bit, but I've kept the old bell as a keepsake," Donna said. "We cater to our folks," she chimed in. "If they call in an order, they don't even have to get out of the car. We'll meet them in the parking lot with an order of hot chicken."

VERMILION PARISH

SUIRE'S GROCERY

13923 LA Highway 35 South
Kaplan, LA, 70548

It's a homey grocery store and restaurant where you know what's cooking. As soon as you jump on the front porch, you'll spot the hefty menu hand-printed on the outside. It's called Suire's, it rhymes with beer and, yes, they have that, too.

It's frequented by the lead duck hunter with the chocolate lab named Willie in his truck bed, as well as the fisherman with hopes of coming home with a bounty of blue point crabs. When locals say they are going to the islands for the weekend, they are referring to Cow Island, Pecan Island and Forked Island—all hunting and fishing destinations an easy drive from Suire's, along Highway 35.

Suire's has been a grocery store for more than eighty years, originally called Otto's. With a passion for cooking, Mary Oels dreamed of owning a grocery store and restaurant. When she took the leap in 1976 by buying the place, with a change to the family name of Suire's, she immediately set up her pots and pans to prepare chili dogs and hamburgers for customers.

As her simple fare became popular, she expanded the restaurant by clearing out the storeroom to accommodate a larger kitchen, while dismantling store shelves. The wooden shelves were converted to tables,

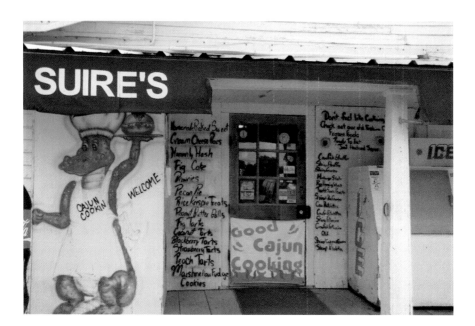

Check out Suire's menu on the front porch. *Photo by author.*

and the grocery store was divided. There's potato chips, beer, water and other staples stacked on one side and "fine dining" on the other side, where six tables are set up. There's a checkerboard on each of the tables.

It's like eating in grandma's kitchen, so mind your manners. It's that kind of cozy place where you can spend your time playing checkers, visiting with folks or checking out local pictures of spoils of the hunt (bullfrogs, string of fish, gators and bucks). A hodgepodge of artwork hangs on the wall, along with an old payphone, washboards, LPs of swamp pop musicians Warren Storm and Tommy McLain and a photo of chef/cookbook author John Besh with the Suire family. Suire's has been featured everywhere from the *Kaplan Herald* to the *New York Times*. All of the reviews are spot-on because the food is great.

Mary's daughters, Joan Suire and Lisa Frederick, take turns running the store and restaurant seven days a week. Each works the store much as a showman does by greeting customers, welcoming newcomers, taking orders over the phone and dishing up lunch. Both girls began working at the store during their teen years, although Joan also had some experience driving a tractor for their father, Newton Suire, a rice farmer. The busiest time at Suire's is the first day of hunting season, when sportsmen come in early to grab the renowned BLT or "divine" chicken salad sandwiches. Homemade sweets include slices of pecan pie, heavenly hash and cookies.

It's best you go on an empty stomach because there is a good-sized menu to choose from. You can call in your order for a po-boy or plate lunch, something hunters do while waiting in their duck blinds. A fitting specialty from the gateway to sportsmen's paradise is Suire's rich and dark turtle sauce piquante filled with chunks of turtle meat. With the abundance of swamps and marshes in Vermilion Parish, the snapping turtle is one of nature's treasures and can be caught in the wild as the main ingredient for this spicy, tomato-based dish. This somewhat exotic entrée has been featured at many local camp cookouts, sporting a distinctive taste reminiscent of several types of meat such as pork, chicken, fish, veal and shrimp, amazingly all in one dish. A spot of sherry is used to enrich the flavor.

You can enjoy the tastes of the country in the daily plate lunch—your luck if it's spaghetti. It could also be chicken stew, which includes sides of salad, a vegetable, a dinner roll and a sampling of a dessert. The freezers are full of containers of gumbo and pistolettes (a popular fried bread roll usually stuffed with seafood), as well as brisket corn soup. All this you can stock up on when you don't have time to visit the "Islands."

Dupuy's Oyster Shop

108 South Main Street
Abbeville, LA, 70510

The pretty little town of Abbeville was named after Abbeville, France, in honor of the hometown of Pere Antoine Desire Megret, a Capuchin missionary who traveled Louisiana waterways in a pirogue. He spent $900 in 1843 to purchase property to establish Abbeville, Louisiana, laying out the town in a similar manner to an old provincial village of France. Narrow streets and small squares were mapped out, as was a unique town center called Magdalen Square, with St. Mary Magdalen Catholic Church, established 1845, facing the square. The town of Abbeville was incorporated in 1850, retaining an old-world charm.

Across from the church is one of the oldest restaurants in Louisiana. With the Vermilion Bay literally in the backyard of Dupuy's Oyster Shop in Abbeville, oyster aficionados have trekked to the historic downtown of Abbeville since 1869. Back then, Joseph Dupuy harvested his own oysters and sold them for a nickel a dozen, beginning a tradition that would continue through three generations of the Dupuy family. Now it belongs to Jody and

Tonya Hebert from Vermilion Parish, who are dedicated to keeping the old family recipes yet creating many new entrées.

Joseph Dupuy steered his boat to a favorite fishing spot at the coastal area of Diamond Reef, watching carefully for the current on the way out and poling his way upriver with a full load of oyster shells. His son, Ferdinand Dupuy, continued in the oyster business.

Jody Hebert began working at various restaurants in the late 1980s, first as a dishwasher and then behind the stove. A few years later, he moved up to assistant chef, learning techniques of French and Italian cuisine. Of course, he knew that it was very important that he perfect cooking gumbo to draw in customers. In the year 2000, he bought the building and the Dupuy Oyster Shop name. Raw oysters brought in from Vermilion Bay are still a main feature on the menu.

Dupuy's is a simple, pieced-together white clapboard building with working shutters. A few years ago, the adjacent building was tacked on. With walls torn down to adjoin to the original building, an oyster bar atop a terrazzo floor from the '50s provides a classy entrance to the restaurant. The décor includes alligator jaws on display and Tabasco® neon signs. Oyster shells are plastered to the ceiling molding along the well-worn brick walls. An outdoor patio with a fire pit is available for dining during cooler weather. The outside view is of the majestic church, overlooking Magdalen Square, accented by large oak trees, a fountain and a gazebo.

There's a ritual to slurping raw oysters and downing them with cold beer—this is what customers line up for. A half dozen half shells are just a teaser to whet your appetite for another iced-down tray of plump oysters garnished with lemon wedges. Dupuy's shucks the oysters upon ordering. Using an oyster knife and years of skill, the shucker pops the hinge until the two shells are separated. It's important not to spill the juice while you neatly cut the abductor muscle without damaging the oyster. With a slight movement of the hand, spear one of the oysters with a shellfish fork and dip into your sauce of choice. A bit of Tabasco® pepper sauce and horseradish adds to the taste. A few chews of the sea gem releases the flavor before it slides down your throat. There's a smooth texture to the oyster, although the taste can be bold, musky or subtle, but still delicious and memorable.

Other oyster dishes aside from ice-cold and salty half-shells are Rockefeller with homemade spinach cream sauce and mozzarella cheese and chargrilled oyster de ville. You can also order the oysters fried on po-boys as a messy delight.

At one time, oyster shops closed during certain months because of the myth that oysters should only be served during months containing the letter

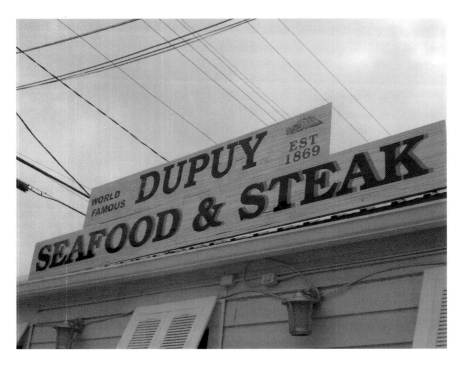

Dupuy's, the oldest oyster shop in Louisiana. *Photo by author.*

r in the name. This is no longer the case, as oysters can be served year-round, although Dupuy's menu has a variety of other dishes as well. Jody Hebert implemented dishes to promote seafood and Cajun hospitality. Fresh fish is brought in weekly, as are alligator, fresh crabmeat and softshell crabs when in season. There's more to salads than lettuce at Dupuys: salads topped with fried catfish, fried alligator and grilled yellow fin tuna or shrimp.

Take it from Shakespeare: "The world is your oyster." The world is ours to enjoy, especially in colorful Abbeville, with an essence of France.

BREAUX'S GROCERY

12998 LA Highway 699
Maurice, LA, 70555

Fadrey Sonnier Breaux admitted that at age ninety-seven and still "sharp as a tack," she is semi-retired from running Breaux's Grocery in Leroy. The

Early days at Breaux's Market in Vermilion Parish, with the family playing in the snow. *Courtesy of Breaux's Market.*

community was originally called La Butte Rouge, because of the Abshire family home that was painted red and easily spotted from a distance. Once a post office was established, the name was changed to Leroy in memory of Dr. Theonis Abshire's son, Leroy, who died of tuberculosis during his youth. Dr. Abshire was one of the original settlers and the first doctor to practice in the area.

Mrs. Breaux bragged that the building that houses the store is actually older than she is. Originally a drugstore at the turn of the twentieth century, it was moved to its current location on Highway 699, which leads travelers from Maurice to Meaux to Morse, all small communities within Vermilion Parish. Eventually, it was taken over by the Vincent family, serving as a country store during the 1920s, and then it was purchased by the Breaux family.

Breaux's Grocery serves "Hot Boudin and Cold Beer," but when it was opened by Otis and Fadrey Breaux in 1944 while the two were in their twenties, there was plenty of competition. "Every corner on every little dirt road had a store," Mrs. Breaux commented. "There were about twenty stores in the area." Breaux's Grocery opened while World War II was in full swing, a solemn era of shortages and rationing. She noted that it was a very emotional time when the war ended in 1945, as church bells rang in

celebration. The store was one of the few places that had a telephone, so when there was news about a local soldier getting harmed or killed, Otis and Fadrey were often the first to be contacted.

Breaux's had general merchandise, groceries and a gas pump. Otis fixed tires, pumped gas and greased cars, while Fadrey worked the cash register in the store. Otis incorporated a special way of dealing with the rice farmers whose income was "on hold" until they harvested their crop. In allowing the farmers to take food essentials on credit from the store, Otis gave them time to pay their bills once the rice came in. Breaux's also had a post office, drawing in customers for daily mail pickup, and a family cattle business, so choice cuts were cut and sold from the butcher block.

Livestock feed was sold in patterned sacks, which proved to be a welcome sight in many country homes to provide some essentials. Mrs. Breaux recalled that patterned feed sacks were used to sew everything from girls' dresses to boys' shirts. Mothers swapped feed sacks with other families to have a variety on hand of colorful patterns to recycle into clothing. Flour and sugar also came packaged in sacks and could be used in a number of inventive home uses, such as dish towels and diapers.

Farmers brought to the store to sell whatever crops were robust in the fields—cucumbers, squash or tomatoes. Baskets of eggs straight from the chicken coop were carried in to trade for sugar and coffee. Otis carted these dozens of eggs to Lafayette to sell. The system of bartering also included chickens raised by farmers, sometimes fresh fish or, if there was a need, help with fixing or building things around the store. Despite the Great Flood of 1927 and numerous hurricanes that hit Vermilion Parish over the years, Breaux's Grocery is on high ground and has never flooded.

"There was no vacation from running the business, just long hours at the store, which opened at 5:00 a.m. to accommodate the farmers of cotton and rice," Mrs. Breaux noted. Behind the scenes at the Breaux home, which was connected to the store, their five children focused on homework or playing basketball, although they all had store duty.

Jerry Breaux, the youngest son of Otis and Fadrey, remembered spending time stocking shelves and serving gasoline, eventually progressing to managing the register. "In the old days, the counter where customers paid was located at the back of the store rather than near the exit. It's a sign that people trusted each other a bit more back then," Jerry recalled.

The store became a gathering place for locals, mostly men. "I can remember as a child hanging around the older men as they talked, mostly

in French," Jerry added. "And although I never really learned to speak or understand it very well, I still liked being around them."

Breaux's is open seven days a week, although on Sundays, there are short hours. There's a country feeling to this simple, wood-framed rectangular shop with ceiling fans gently spinning to cool off customers. It's a great place to stop for boudin, hamburgers, chili dogs, sausage po-boys, chips and a soda pop. There's a bench on the porch for visiting and a little table for enjoying a picnic.

Fadrey Sonnier Breaux, known in Leroy as "Miss Fed," passed away on January 26, 2015, a loving mother to five children, ten grandchildren, fourteen great-grandchildren and seven great-great-grandchildren.

Rationing during World War II

World War II had a huge influence on America's small-town grocery stores, primarily through the rationing of staples at the onset of the war.

Under President Franklin D. Roosevelt, the Office of Price Administration (OPA) spearheaded an equitable distribution of goods at fair prices while controlling hoarding and fighting inflation. The OPA was responsible for two types of rationing programs. The first limited the purchase of bigger commodities, such as tires, bikes, cars and metal typewriters. The second was a food rationing program, which limited the quantity of foodstuff such as butter, coffee and sugar. The first food to be rationed was sugar in 1942, leading to a big change in preparing cakes and cookies.

More than 120 million copies of the War Ration Book One were issued to registered families, based on the number in the household. The books contained stamps that could be used to purchase food items. With this new program and color-coded ration stamps in hand, eating habits changed drastically because of wartime shortages.

It became every citizen's duty on the homefront to cut back. While eyeing the somewhat bare shelves at the grocery store, housewives learned to be creative with menus and scale down on their purchases by budgeting stamps as well as money. Bakeries were obviously affected by the shortage of sugar, often using honey or corn syrup as a sugar substitute to prepare some sweets. In restaurants throughout the country, sugar bowls disappeared from dining tables.

Rationed items were expanded to include canned goods, red meat, dairy products and fats. Each person in a family had forty-eight points worth of

World War II ration book. *Courtesy of the Galbert Huval family.*

ration stamps per month for canned, dried and frozen foods. A can of corn (one pound, four ounces) was fourteen points, a can of pears (one pound, fourteen ounces) was twenty-one points, a pound of ground beef equaled seven points, a pound of butter was sixteen points (a pound of margarine cost only four points) and a bottle of ketchup was fifteen points. The stamps

had to be used along with cash when buying these items at the store. A big responsibility was dropped on shopkeepers to monitor announcements about the somewhat baffling system of rationing stamps. It was much more than supporting the war effort; it was a government-mandated program. To prevent hoarding of the stamps, expiration dates were placed on the stamps.

To survive the food shortages, Louisianians adapted to the wartime sacrifices. Many had already experienced deprivation during the Great Depression and coped in similar ways. Coffee grounds were used more than once to prepare a pot of coffee, though the second helping was weaker. Families were encouraged to observe "Meatless Tuesdays" by substituting traditional red meat dishes for chicken and eggs. Ever resourceful, many Cajuns raised chickens or pigs even before the war began, so they were able to continue cooking their beloved gumbo. Cornbread squares or bowls of couche-couche were an inexpensive breakfast. Syrup cake (gateau de sirop) could be baked without using sugar.

While fresh produce became harder to find as the war continued, another incentive was formed to stretch meals. Neighborhood victory gardens were encouraged, leading to more fresh produce and more home-canned goods. Since canning required sugar and sugar was rationed, women who canned earned the bonus of additional sugar. A special application had to be filled out to certify how much they expected to can. Some 20 million Americans planted gardens in every backyard nook. The slogan "A Garden Will Make Your Rations Go Further" encouraged Americans to till their own soil for planting cabbages, tomatoes, potatoes, radishes, corn and squash. When the war ended in 1945, so did the rationing of commodities. There were scenes of merriment, with confetti thrown in the air, frantic hugging and kissing, unbridled cheering and weeping. Sounds of whistles, sirens and bells celebrated the return to peacetime.

LAGNIAPPE

Local Products

JACK MILLER'S BARBEQUE SAUCE

646 Jack Miller Road
Ville Platte, LA, 70586

Lagniappe is a Cajun word for "a little something extra." There are many foodstuffs that enhance our Cajun culinary delights. Where would food lovers be without that extra spice or without rice for gumbo? Here is one popular addition that serves as a companion to our world-famous cuisine.

It was a gamble for Jack Miller to create his barbecue sauce of seventeen ingredients in the 1940s. Jack Dosite Miller and his wife, the former Joyce Chapman, were already in the middle of running the American Inn Restaurant in Ville Platte. Dishing up standard fare, prices were fifteen cents for a hamburger and fifty cents for a steak dinner. This was at the onset of World War II, and rationing limited kitchen staples. Beef and pork were hard to find to feed customers, but Jack was spunky and negotiated with chicken farmers. The menu was modified to feature barbecued chicken, sending Jack back to experimenting with flavors at the stove to concoct a sauce to brush on chicken parts. Catering for family gatherings and parties helped spread the word around for miles about the delicious barbecue chicken. The saucy bird with the sweet and spicy taste became so popular that customers lined up to buy quarts of the sauce to use in other dishes as well.

Having been raised on a one-hundred-acre farm in Sunset, Louisiana, Jack had learned how to cope with most challenges: long days in the field, a broken-down tractor, poor crops and lots of siblings at the table in a family of twelve. Choosing to spend time working in his grandfather's grocery store and community restaurants seemed preferable to the backbreaking task of picking potatoes and cotton in the fields.

For nearly twenty years, the Millers cultivated their restaurant business. But it was the growing demand for the sauce that created an unexpected success. In 1962, the Millers shut down their restaurant business and concentrated on the barbecue sauce in the dining room, overseeing the kitchen conversion to workstations to accommodate preparation of the barbecue sauce full-time. Kermit Miller, Jack's son, remembered, "We

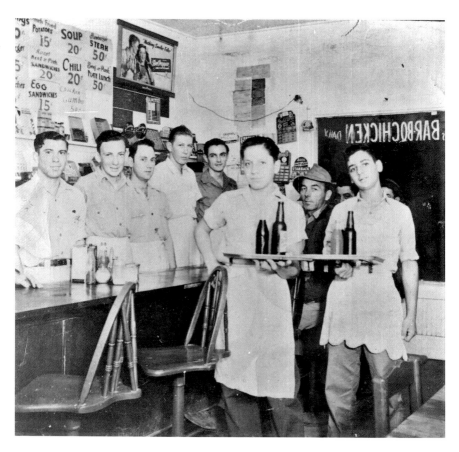

Jack Miller's American Inn, where his famous barbecue sauce originated. Standing behind the counter first on left is Jack D. Miller. *Courtesy of Kermit Miller.*

used six-gallon pots on the stove and stirred constantly. Dippers and funnels were used to pour the sauce in canning jars. We started small." So enthusiastic was Jack about his sauce and barbecuing that he once had a pit going while actually riding on a parade float in a Fourth of July celebration. This festival became the annual Cotton Festival in Ville Platte.

Kermit described the Miller Sauce as "tangy" and "onion-y." An expert at peeling onions, beginning at age nine, Kermit recalled that they peeled 250 pounds of onions per week. Unfortunately, Kermit has never come up with the best way to prevent crying during this duty. Nowadays, Kermit oversees the business, and his son, Christian (third generation), is also involved. After a stint with the U.S. Navy, Kermit attended college, focusing on business, bookkeeping and marketing. Aside from the college studies, Kermit acknowledged that with all the machinery involved in producing barbecue sauce, being familiar with mechanics and plumbing is important. He's been with the company for forty-four years. "It was always my plan to join the family business someday," Kermit mentioned.

Evangeline Parish has more of a French heritage than a Cajun heritage, with both of Kermit's parents fluent in French. Although their first language was French, they learned enough English to get by. "When they attended school, many Cajun children, including my parents, were punished if they spoke French," Kermit acknowledged.

Jack Miller's is known as the "Sauce with a Cajun Accent," guaranteed to give backyard barbecues that extra kick straight out of the bottle on ribs, steaks and chicken parts. It's not "one size fits all," as the sauce is available in sizes from eight ounces to one gallon, complementing many dishes. Jack Miller's also produces two Cajun seasonings, one minus the salt. The Cajun Dipping & Cocktail Sauce is like a spicy ketchup and good with seafood, especially boiled crawfish.

Kermit and his wife, Sheila, enjoy the meet and greets at food shows and local grocery stores to demonstrate their sauce. When Sheila heats up tastings of meatballs or her shrimp dip, the aroma draws in hungry customers for a sampling.

The Miller production site remained on the main drag in Ville Platte until 1980, when the highway came through. Now stationed in a seven-thousand-square-foot modernized processing plant a few miles away, the original recipe is still used.

"We cook three kettles of 350 gallons at one time, slow-cooking on low heat to get the flavor," Kermit said. "We produce 700 gallons a day, four days a week, although we can go up to 1,000 gallons. We usually take Fridays to clean up and give the machines a tune-up." He recognized that the sauce

is more in demand during the summer, when families are outdoors and grill more often. Although producing the sauce remains a year-round process, they've come a long way from filling canning jars by hand. The sauce goes through a cooking process in kettles heated by steam and then is pumped into the filling/packing room. Bottles are filled and capped by machine, cooled off, labeled, boxed and ready to go.

Miller's Sauce is sold to grocers throughout the United States. Kermit recognized that special orders allow cases of the sauce to travel overseas. "Likely it's for some Cajuns working overseas in Norway and Iceland that are lonesome for spice in their dishes," Kermit joked.

Bergeron's Pecans

10003 False River Road
New Roads, LA, 70760

As nature's health food, the amber-colored pecan stars in pralines and pecan pies during the holidays. It brings something new to the table as a crusty coating for preparing fish and chicken and as a crunchy tidbit to sprinkle on salads.

There was a time when harvesting pecans in the autumn coolness meant knocking them out of a tree by swinging a long cane pole, stooping down to pick them up and hand-cranking the nut cracker. Bergeron's Pecans has come a long way from 1910, when Horace Joseph Bergeron opened a country store in New Roads along False River. The land along the river proved fertile for growing a bounty of pecan trees, making Pointe Coupee Parish the largest-producing parish of pecans in Louisiana. The Bayou State consistently ranks fifth or sixth in the United States as a pecan-producing state. Country stores throughout Louisiana post homemade "We Buy Pecans" signs during pecan season from October through February, with prices per pound rising according to demand of the market.

H.J. Bergeron accommodated the farming community by stocking basic needs. He began buying pecans from home pickers and sharecroppers as they dragged in sacks of pecans. Gradually turning to the thriving business of pecans, he had them hand-shelled, selling them to local candy makers as well as to New Orleans confectioneries.

Many years of hand shelling continued until 1941, when Lester and Bennett Bergeron built the current shelling plant beside the old country

A common sign in the fall in the country. *Photo by author.*

store. Machinery was installed to accomplish the many stages necessary for pecan shelling, and the sideline business of pecans became the main one.

André (third generation), whose first job in the family business was buying pecans from home pickers, manages pecan production along with brother Steve and cousin Lester. They have become experts in all aspects of growing, buying and processing pecans, to the tune of 6 to 7 million pounds of pecans annually.

The Bergerons buy pecans throughout the state, although they do own a local four-hundred-acre orchard as well. They lost 30 percent of their trees to Hurricane Gustav in 2008. "Crops can be unpredictable. The pecan business has some challenges, and weather is a big one—hurricanes and drought, which of course affect pricing," André said.

There's a syrupy scent in the air when the plant is running during the busy season. Preferences are for the native Louisiana pecan, with a high oil content, and the Elliott variety, which has a robust, sweet flavor. The "big claw," a machine that shakes the trees, is still used to knock pecans off the high branches of the tree. Another machine similar to a street sweeper picks up the pecans that have fallen to the ground. It beats the old way of hand picking!

Pecan pie, a popular Louisiana dessert. *Courtesy of the Louisiana Department of Culture, Recreation and Tourism.*

Many steps of sterilization and grading are involved to secure the sweet meat of a pecan. Placing the pecans in a hot water bath removes the dirt, giving the nuts a thorough cleaning. Drying to control the moisture follows. Grading and sizing are important for the next steps, which include cracking and shelling. Machines are set precisely to crack the pecan in the right spot, at one thousand pecans per minute. After some tumbling and shaking, the meat is separated from broken shells. Electric eyes help to sort the shell and foreign matter from the meat. There is still a bit of the human touch when the halves and pieces are rolled out on conveyor belts separately to the watchful eye of workers checking for quality and consistency. Bags of pecans are sold in bulk for distribution to feed stores, foodservice markets, grocery stores, candy makers and restaurants. Pecans are also bundled in huge containers and stacked in cold storage.

Although picking pecans is customary in the fall and winter, pecans are a year-round business. During the summer, the plant goes through an overhaul to check the equipment and plan for a new season, although pecans (fancy shelled halves, bits and unshelled) are shipped year-round.

In 1990, Bergeron cousins founded Pointe Coupee Pecans, taking pecans lovers one step closer to heaven by using Bergeron shelled pecans to make sugared pecans, chocolate pecans and praline crunch.

KONRIKO RICE MILL

307 Ann Street
New Iberia, LA, 70560

What would supper be without a steaming mound of fluffy rice in our gumbo? It would be a sad day at the kitchen table if rice were missing from our jambalaya and crawfish étouffée.

Rice has been an important crop in Louisiana since the 1880s. It was introduced to our state by explorer Bienville's French colonists as early as 1718, though largely confined to growing in the lowland region along the Mississippi River Delta at one time.

King sugar once reigned supreme on our plantations, but that changed after the Civil War, when rice became a valued crop. Today, Louisiana alternates with Texas as the third-largest rice producer in the United States, with Americans eating twenty-five to thirty-five pounds of rice per person annually. Not surprisingly, rice consumption in Louisiana is double that amount because of Cajun dishes and southern soul food.

Konriko Rice Mill, located in New Iberia, is the oldest operating rice mill in the country, getting the job done with a rare, belt-driven system in the factory. The mill was placed on the National Register of Historic Places in 1981. The Konriko name is a close acronym of Conrad Rice Company (KON-RI-KO).

Founder P.A. Conrad had a bounty of rice fields. In transporting the rice by steamboat to New Orleans, the process became time-consuming and expensive. As a way to harvest his field crops, Conrad built his own mill in 1912, running it from September through Christmas. His techniques included cutting rice by hand. It was sun-dried on the levees and shoveled into threshing machines and then stuffed into one-hundred-pound sacks to haul to the mill.

Former schoolteacher and farmer Mike Davis and his wife, Sandy, bought the Conrad mill in 1975. At that time, Konriko produced white rice for only three grocery stores. It's a testament to Louisiana ingenuity that the Davis family has added so many new products since acquiring the mill.

Konriko, America's oldest rice mill. *Photo by author.*

Times have changed, although much of the processing and machinery have not. A continous line shaft controls the milling machinery with pulleys and old leather belts on the mill's second floor, serving as a glimpse into nineteenth-century mechanics. More than forty thousand pounds of rice are processed per day. The silo holds 1 million pounds of rice when full.

The mill works in a "slow and gentle traditional fashion," using a series of cleaning, paddy separation with a 1926 paddy machine and milling to produce a variety of rices.

One of the last steps in the processing is when the rice moves to the grain separator, where it is sorted by size. The company sells rice bran for livestock feed to farmers, while the broken grain is used to make rice flour or sold to breweries for making beer.

Produced exclusively by Konriko, Wild Pecan Rice is a misnomer because there are actually no pecan pieces in the rice. The name of this delicious rice stems from the nutty flavor and aroma. Only a small percent of the outside bran layer is removed through the milling process, just enough to release the unique flavor of roasting nuts.

As visitors tour the old mill, the constant sounds of grinding and creaking of the machinery can be heard, just like in the old days. Fluffy rice is cooked every day for sampling in the Konriko Company Store. Also tempting is

Konriko's R.M. Quigg's line, which includes yellow rice, paella rice and black beans and rice mixes.

Another line is Hol-Grain, popular with the gluten-free customer. Available are rice crackers, brownie mixes, pancake mixes and crispy chicken coating mix (using rice flour).

STEEN'S PURE RIBBON CANE SYRUP

119 Main Street
Abbeville, LA, 70510

The shrill sound of the steam whistle blowing and the sweet aroma of sugar floating in the air signals that it's cooking time for Steen's Pure Ribbon Cane Syrup. The simple and buttery taste of this Louisiana sugar cane syrup has pleased country cooks and chefs of haute cuisine for more than one hundred years.

Children in south Louisiana grew up chewing blocks of sugar cane for the juicy pulp inside. Considered a tropical grass that grows ten to twenty feet tall, sugar cane is a major source of commercial sugar. It has played an important role in Louisiana's culture, providing an annual economic impact of $3.5 billion. According to the American Sugar Cane League, 1.4 million tons of raw sugar are produced on more than 400,000 acres of land in twenty-two Louisiana parishes.

Jesuit priests first brought sugar cane into south Louisiana from Santo Domingo during the mid-1700s. The variety of this early cane "Creole" was sweet and popular for chewing. Credit is given to planter Etienne deBoré for perfecting the process of sugar crystallization (1795) at his New Orleans plantation, the home of present-day Audubon Park.

The C.S. Steen Syrup Mill of Abbeville is one of the few sugar cane syrup mills in the country. In 1910, farmer C.S. Steen faced a dilemma. A crop of six hundred tons of frozen cane was standing in his field. Losing this crop would have been financially devastating. Limited transportation to the nearest refinery miles away presented a further challenge. His father had been a sugar boiler by trade, and he recalled helping when his father's cane crop had suffered early freezes. With this prior experience, he purchased a small mill from a local hardware store. In a true pioneer spirit, a financial disaster was avoided by setting up a little mill, salvaging the frozen sugar cane crop by grinding the cane and cooking the syrup to produce three barrels of thick syrup.

Steen's Pure Ribbon Cane Syrup. *Photo by author.*

The following year, when he produced a better crop and upgraded his process, C.S. Steen was officially founded. The average "syrup making" season ran from October through Christmas. After sugar cane stalks were cut by hand, they were drawn into the mill by wagons to produce a few barrels per day.

Other farmers of the area were excited about the mill and began hauling their sugar cane crops to Steen's, returning home with wagons of wooden barrels and tin cans filled with the finished product, which was syrup.

Today, five generations of Steen's later, the mill still uses the original recipe and steam equipment to make cane syrup the old-fashioned way by open kettle. The sugar mill crushes the sugar cane stalks and squeezes the juice from the plant. The cooking kettles of pure sugar cane juice are evaporated to form cane syrup until the taste is right while producing a rich caramel coloring. It's a process in which no refined sugar is removed.

There are countless ways to use the syrup for breakfast, desserts, meat and seafood. A simple (to bake) though not too sweet Cajun cake without frosting is the gateau de sirop (syrup cake). Or, out of the cupboard comes a bright yellow old-time can of Steen's to pour on a stack of pancakes or on hot-buttered biscuits. It's also great for making pecan pies and popcorn balls, yet it's tasty as a glaze on hams and pork chops. The toasty flavor of Steen's is also a good addition to baked beans, sweet potato dishes and salad dressing.

TABASCO® BRAND PEPPER SAUCE
Avery Island, LA, 70513

Tabasco® Brand Pepper Sauce is served on a silver platter in the most elegant restaurants in Paris, New York and London. Diners find it in country restaurants and in far-flung locations. This unique condiment is a cupboard staple for most home cooks. Across the globe, Tabasco® pepper sauce—made from tabasco peppers, vinegar and salt—guarantees Avery Island in Iberia Parish a memorable place on the map.

Avery Island is not actually an island but rather a roughly 2,200-acre dome of rock salt, with the highest point 163 feet above sea level, surrounded by marshland. It was formed when an ancient seabed evaporated (depositing pure salt), rose up in large chunks and pushed the ground up into a hill.

According to one oral tradition, Edmund McIlhenny, a New Orleans banker in the 1850s, was given a gift by a soldier who was en route from Mexico to New Orleans. The soldier had acquired dried peppers during the Mexican-American War in the late 1840s. He suggested that McIlhenny might enjoy a new sensation by adding some of the peppers to his food. McIlhenny saved the seeds and planted them in the family garden at Avery Island. During the Civil War, McIlhenny and his family moved to Texas for safety. Upon their return a few years later, they found that the plantation was in shambles, but luckily the crop of capsicum hot peppers had survived.

Locating his experiments to the plantation "laboratory" (reputedly once a pigeon house), McIlhenny experimented with what was left of the crop. He crushed the ripe red peppers and added Avery Island salt. After aging the "mash" for thirty days, he added French white wine vinegar to the mixture, followed by an additional thirty days of aging and filtering out pepper skins and seeds to concoct a spicy sauce. Today, the aging process takes up to three years.

Cologne bottles were collected, filled with sauce and distributed as samples to families and gradually to wholesalers. McIlhenny began to produce the pepper sauce commercially in 1868, with first sales going to restaurants and men's clubs in New Orleans. The pepper sauce was named "Tabasco," a name of Mexican-Indian origin meaning "land where the soil is humid" or, according to a more recent etymology, "place of coral or oyster shell."

The special peppers are grown throughout Central and South America, in Africa and, of course, in the home fields of Avery Island. All seeds are still

A Tabasco® advertisement from 1899. *Courtesy of Tabasco.*

grown on Avery Island, where five generations of the McIlhenny family have overseen the pepper sauce empire. The process includes hand-picking the peppers from the fields. *Le petit baton rouge* (little red stick) is still used to match the colors of the peppers to the stick to ensure that the color is right and that the peppers are at their juiciest. Weighing, sorting and processing lead to the aging stage, where the mashed peppers are allowed to ferment in secondhand bourbon barrels from Kentucky for up to three years—seemingly a long process, but as the slogan says, "There is only one TABASCO®."

Today, Tabasco® sauce is labeled in twenty-two languages and dialects and sold in more than 180 countries and territories. More than 700,000 bottles of the Tabasco® Brand Original Red Sauce are manufactured daily. Since the 1980s, the United States has included Tabasco® hot sauce in soldiers' MREs (Meals, Ready-to-Eat), and the British and Canadian armies have also included it in their soldiers' rations. It is popular at the White House and has flown into orbit aboard space shuttles. There are seven flavors of the potent stuff, including the original, chipotle, green jalapeño, habanero, sweet-and-spicy, garlic pepper and buffalo-style. Other products include soy sauce, ketchup, salsa, barbecue sauce and pepper jellies. For something sweet yet spicy, a dash of the legendary pepper sauce is added to Tabasco® chocolate wedges for the right "bite."

The Tabasco® marks, bottle and label designs are registered trademarks and service marks exclusively of McIlhenny Company, Avery Island, Louisiana, 70513. www.TABASCO.com.

RECIPES

TEET'S SMOKED JALAPEÑO CHEESE SAUSAGE AND CAJUN SHRIMP PASTA

*Courtesy of Teet's Food Store / Specialiste dans la Viande Boucanee,
Ville Platte, Louisiana*

1 small onion, diced
1 small bell pepper, diced
1 pound of Teet's Smoked Jalapeño Cheese Sausage
2 cups of water or seafood stock
15 ounces of Alfredo sauce
1 pound of shrimp
½ stick of butter
1 bundle of green onions, chopped
1 pack of penne pasta

OPTIONAL:
1 cup of parsley, chopped
garlic bread

SEASONING MIXTURE:
2 tablespoons of garlic powder
3 tablespoons of your favorite Cajun seasoning
3 tablespoons of Italian seasoning

Place diced onions and bell peppers into your favorite pot and cook/brown until they are almost translucent/browned. Add the smoked jalapeño cheese sausage to the pot and brown all together. This sausage adds a little extra dose of cheese that creates a wonderful flavor! Once browned, add the water or stock and Alfredo sauce and let it simmer while you cook the shrimp.

Season the shrimp with the included seasoning mixture. Feel free to add more seasoning if you're up for it! Place the butter in a black iron skillet and melt. Add shrimp and cook until no longer clear. Once cooked, add the shrimp to the sauce mixture and add the green onions. Mix well and put on low heat and cover.

Cook the pasta in accordance with the package directions. Drain pasta and mix the pasta into the sauce. Let it cool before serving.

Pork or Shrimp Fried Rice

Courtesy of Konriko Rice Mill, New Iberia, Louisiana

1 cup Konriko Wild Pecan aromatic rice
½ pound boneless pork cut into small cubes, or peeled medium shrimp (about 1 cup)
1 tablespoon soy sauce
2 teaspoons Asian sesame oil, divided
2 teaspoons Konriko Creole seasoning, divided
2 large cloves garlic, minced
1 tablespoon fresh ginger, minced
3 eggs
3 tablespoons peanut oil, divided
3 green onions, thinly sliced
1 cup bean sprouts
½ cup frozen green peas (optional)

Cook rice according to package directions (omitting butter), spread in a shallow pan and chill well. In a small bowl, combine pork or shrimp, soy sauce, 1 teaspoon sesame oil, ½ teaspoon Creole seasoning, garlic and ginger; mix well and set aside. In another bowl, beat eggs with ½ teaspoon Creole seasoning and remaining 1 teaspoon sesame oil.

Heat a wok or large skillet until hot over medium-high heat. Add 1½ teaspoons peanut oil and swirl around wok 'til hot. Add

pork mixture and stir-fry 3 to 4 minutes or until pork is done; remove from wok and set aside.

Add remaining 1½ tablespoons peanut oil to wok and swirl in pan until hot. Add egg mixture and stir-fry 1 minute or until egg is done. Add cold rice and stir-fry 3 to 4 minutes. Add green onion, bean sprouts, peas (if desired), remaining 1 teaspoon Creole seasoning and cooked pork. Stir-fry 2 minutes longer and serve immediately. Makes 6 servings.

T-Jim's Cajun-Stuffed Pork Chops

Courtesy of T-Jim's Grocery & Market, Cottonport, Louisiana

4 center-cut pork chops, 1½ inches thick
¼ to ½ pound of fresh pork sausage
Season-All or Tony Chachere's seasoning, to taste
1 cup plus 2 tablespoons water, divided
2 tablespoons gravy mix or instant roux
green onions (optional)

Make horizontal slit with sharp knife through each pork chop. Squeeze sausage from casing and stuff each pork chop with approximately 3 tablespoons of sausage mixture. Season pork chops with Season-All or Tony's. Spray Dutch oven or baking pan with PAM. Add pork chops to pan with 2 tablespoons water. Bake covered at 375 degrees for approximately 1 hour. Mix 1 cup water and 2 tablespoons of gravy mix or instant roux and add to pork chops. Continue baking approximately 30 minutes. Top with green onions and serve over steaming rice or mashed potatoes.

Granny Roy's Bread Pudding

Courtesy of St. Gabriel Grocery & Deli, St. Gabriel, Louisiana

18 slices of bread
1 cup sugar
1 can evaporated milk
2 cups milk

1 teaspoon vanilla
4 eggs
⅓ cup butter

Mix all ingredients together and bake for 20 minutes at 350 degrees Fahrenheit. To prepare a larger amount, use a whole loaf of bread (large) and triple the other ingredients.

Eggplant Dupuy

Courtesy of Dupuy's Oyster Shop, Abbeville, Louisiana

2 whole eggplants
1 quart buttermilk
5 cups breadcrumbs
2 quarts heavy whipping cream
3 cups diced tasso
2 tablespoons dry basil
¼ cup green onions, chopped
1 tablespoons minced garlic
2 tablespoons parsley, chopped
½ cup melted margarine
1 cup flour
1 pound baby shrimp (peeled)
1 tablespoon salt
1 tablespoon black pepper
2 quarts of vegetable oil

Peel eggplant; slice in ¼-inch-thick round medallions. Dip eggplant medallions in buttermilk and then in breadcrumbs (repeat twice). Set eggplant aside until later. In a medium-size pot over medium heat, pour heavy cream, tasso, dry basil, green onions, minced garlic and chopped parsley and let it cook for 15 minutes, stirring occasionally. In a small bowl, mix melted margarine and flour to make a white roux mix until thick paste forms. Add small amounts of white roux to sauce until slightly thick. Add shrimp, salt and pepper (to taste) to the sauce and cook until shrimp are done. Fry eggplant in vegetable oil until golden brown. Place eggplant on plate, add shrimp, tasso and herb cream sauce on top of eggplant. Excellent as an appetizer or may be served on pasta.

APPENDIX A

GATEAU DE SIROP (SYRUP CAKE)

Courtesy of Steen's Pure Ribbon Cane Syrup, Abbeville, Louisiana

½ cup vegetable oil
1½ cups Steen's Pure Cane Syrup
1 egg, beaten
1 teaspoon ginger
½ teaspoon cloves
½ teaspoon salt
2½ cups sifted flour
1 teaspoon cinnamon
1½ teaspoons baking soda
¾ cup hot water

Heat oven to 350 degrees Fahrenheit. Grease and flour a 9-inch square pan, a 13½- x 8½-inch pan or muffin pan(s). Combine oil, syrup and beaten egg. Stir until well blended. Mix and resift dry ingredients except soda. Add dry ingredients to the oil, syrup and egg mixture alternately with the hot water in which the soda has been dissolved. Begin and end with flour mixture. Pour into prepared pan. Bake 45 minutes. Variation: Chopped pecans or raisins may be added to the mixture.

SOUTHERN GENTLEMAN PECAN PIE

Courtesy of Steen's Pure Ribbon Cane Syrup, Abbeville, Louisiana

¼ cup butter or margarine
1 tablespoon all-purpose flour
¼ teaspoon salt
1 tablespoon cornstarch
1½ cups Steen's Pure Cane Syrup
½ cup sugar
2 eggs
1 cup pecans
1 teaspoon vanilla
unbaked pastry for 1 medium-sized pie

Melt the butter, add flour, salt and cornstarch and stir until smooth. Then add syrup and sugar and boil 3 minutes. Cool. Add beaten eggs, nuts and vanilla, blending well. Pour into pan lined with unbaked pastry. Bake in hot oven at 450 degrees Fahrenheit for 10 minutes and then reduce to 350 degrees and bake 30 to 35 minutes.

CRAWFISH CORNBREAD

Courtesy of Café Des Amis, Breaux Bridge, Louisiana

3 medium (or 1 large) onions, chopped to sauté
⅓ pound melted butter (or 8 tablespoons)
4 cups cream-style corn
2 tablespoons garlic, minced
6 eggs
4 cups yellow cornmeal
6 teaspoons baking powder
2 teaspoons salt
1 teaspoon cayenne pepper
1 teaspoon house seasoning
2 cups milk
4 teaspoons sugar
2½ cups shredded cheddar cheese
1 pound crawfish tails

Sauté chopped onions in 1½ teaspoons of whole butter. When onions are almost tender, add cream-style corn and minced garlic. Remove from heat and add the mixture to a large bowl along with all remaining ingredients, including the crawfish tails. Pour into a 2-inch-deep pan that has been sprayed with nonstick coating. Bake at 375 degrees Fahrenheit for about 1 hour or until cornbread is firm and a knife pulls clean from the center.

APPENDIX A

QUICKIE HONEY-CHIPOTLE GRILLED WINGS

Courtesy of Tabasco®, Avery Island, Louisiana

⅔ cup honey
½ cup Tabasco® Brand Chipotle Pepper Sauce
3 pounds chicken wing drumettes

Heat grill to medium heat. Combine honey and Tabasco® chipotle sauce in a large bowl and set aside. Place wings on grill and cook until crisp and cooked through, about 15 minutes. Transfer hot wings to the large bowl and toss until wings are well coated. Serve immediately. Makes 6 appetizer servings. Recipe can easily be doubled or tripled.

CHIPOTLE BBQ PULLED PORK

Courtesy of Tabasco®, Avery Island, Louisiana

2 tablespoons olive oil
1 (2½ pound) boneless pork roast
½ teaspoon salt
¼ teaspoon pepper
¾ cup ketchup
¼ cup cider vinegar
2 tablespoons brown sugar
2 tablespoons Tabasco® Brand Chipotle Pepper Sauce
1 teaspoon paprika
1 teaspoon Worcestershire sauce
6 rolls

Heat oil in large skillet over medium heat. Season pork with salt and pepper and brown on all sides. Combine ketchup, vinegar, sugar, Tabasco® chipotle sauce, paprika and Worcestershire sauce in slow cooker. Add pork and 2 teaspoons of the skillet drippings; cover and cook on low for 8 hours.

Alternatively, brown meat in oil in an oven-safe Dutch oven or large skillet with cover. Then combine ketchup, vinegar, sugar, Tabasco® chipotle sauce, paprika and Worcestershire sauce and add to Dutch oven or skillet. Cover and bake in 350-degree oven for 4 hours or until fork tender. Shred meat, toss in sauce and serve on rolls. Makes 6 servings.

APPENDIX A

BUTTERMILK PIE

Courtesy of the Cabin Restaurant, Burnside, Louisiana

2 cups sugar
1 teaspoon cinnamon
1 teaspoon vanilla
2 tablespoons cornstarch
¼ pound melted butter
3 large eggs
1 cup buttermilk

Mix all ingredients except buttermilk on slow speed until well blended and uniform. Add the buttermilk and mix well. Pour into an unbaked 9-inch pie shell and bake at 350 degrees Fahrenheit for 40 minutes, or until set and brown on top.

BUTTERBEANS AND SHRIMP STEW

Courtesy of Nobile's Restaurant, Lutcher, Louisiana

¼ cup cooking oil
1½ tablespoons flour
½ bell pepper, chopped fine
1 medium onion, chopped fine
1 stalk of celery, chopped fine
2 pods of garlic, chopped fine
1 pound butterbeans (frozen lima beans)
1 pound shrimp with heads on (70–90 count, peel fresh shrimp yourself)

Heat oil and flour and keep stirring to make a roux until the color is golden brown (not dark). Sauté pepper, onion, celery and garlic until limp. Add butterbeans and shrimp and cook 10 minutes. Add 3 cups of water and simmer 30 minutes to 1 hour. Season to taste with salt and cayenne pepper.

APPENDIX A

KIM'S JINGLE CHICKEN

Courtesy of Jack Miller's Barbeque Sauce, Ville Platte, Louisiana

3 to 5 red potatoes, sliced ½-inch
2 to 3 raw carrots, cut 2- to 3-inch
1 fryer, cut up
Jack Miller's Seasoning to taste
1 onion
½ cup 7 Up, Sprite or ginger ale
½ cup Jack Miller's Barbeque Sauce

Cover bottom of greased baking pan with sliced potatoes and carrots. Place fryer pieces on top of carrots and potatoes. Season fryer and vegetables. Cut up onion over fryer and vegetables. Bake in oven at 350 degrees Fahrenheit for 30 minutes. Remove dish from oven. Mix 7 Up, Sprite or ginger ale with barbecue sauce and pour over fryer and vegetables. Return to oven and continue to bake at 350 degrees, basting often until done, about 45 minutes to 1 hour longer.

SHEILA'S MEATBALL SAUCE

Courtesy of Jack Miller's Barbeque Sauce, Ville Platte, Louisiana

1 pint Jack Miller's Barbeque Sauce
1 to 2 cans cream of mushroom soup, depending on desired consistency
(do not dilute soup)

Mix sauce with mushroom soup. Pour in chaffing dish over miniature meatballs or party sausages. Serve hot.

APPENDIX A

CABBAGE CASSEROLE IN RICE COOKER

Courtesy of Bayou Cabins, Breaux Bridge, Louisiana

1 cup water
1 cup uncooked rice
1 can of Rotel tomatoes
1 cup of mix of chopped onions, bell peppers and celery
1 bag of shredded cabbage
1 pound ground beef
1 pound diced smoked sausage

Mix all ingredients in a rice cooker and set to "Cook" about 30 minutes.

BANANA CAKE

Courtesy of Cannetella's, Melville, Louisiana

1 cup Crisco shortening
1½ cups sugar
2 eggs
2 cups flour
1 teaspoon baking soda
¼ teaspoon salt
3 very ripe mashed bananas
1½ cup chopped pecans

ICING:
1 pound powdered sugar
1 stick butter/margarine, softened
1 small ripe mashed banana
½ cup chopped pecans

In order, mix Crisco, sugar, eggs, flour, baking soda, salt, bananas and pecans. Mix all well to make a thick batter. Pour into a greased and floured tube pan and bake at 325 degrees Fahrenheit for 55 minutes or bake in layer pans at 350 degrees for 25 minutes. Mix the icing ingredients and ice cake.

APPENDIX A

MEMAW'S SPAGHETTI GRAVY

Courtesy of Cannatella's, Melville, Louisiana

1 large onion, chopped
several cloves of garlic, minced
2 small cans tomato paste
1 small can tomato sauce
1 can tomato soup
4 paste cans of water
basil to taste (makes sauce sweet; add this before the sugar)
sugar to taste

Brown onion and garlic in small amount of oil in large pot; add paste, sauce, soup and water. Then season with the basil and sweeten with sugar. Salt and pepper to taste. If you want to make meat sauce, follow same recipe but brown ground meat and Italian sausage and add this to sauce. It's a nice touch to add boiled eggs to the sauce and simmer for 1 hour.

PETE'S ITALIAN HAMBURGER

Courtesy of Cannatella's, Melville, Louisiana

5 pounds ground chuck
1 tablespoon salt
1 teaspoon red pepper
1 teaspoon black pepper
2 tablespoons grated Romano cheese
3 stems green onion, cut fine
6 pods garlic, cut fine
½ medium bell pepper, cut fine
1 rib celery, cut fine
2 tablespoons parsley, cut fine
10 bread slices for bread crumbs
5 large eggs

Season meat with salt, red pepper, black pepper, Romano cheese, green onion, garlic, bell pepper, celery and parsley. Make bread

crumbs. Beat eggs lightly. Pour into bowl and blend into bread crumbs. Mix this into meat mixture. Make patties. Can be pan cooked, grilled or baked.

GLOSSARY OF POPULAR CAJUN DISHES

Frying crunchy cracklings. *Photo by author.*

andouille (ahn-doo-eee): Pork sausage that is heavily spiced and smoked. Popular ingredient to add in Cajun cuisine such as jambalaya and gumbo.

au gratin (oh-graw-ten): French cooking term used to describe a rich, sauced dish, usually topped with bread crumbs and cheese, such as crabmeat au gratin.

beignets (ben-yea): Fried pastry similar to a doughnut but without the hole, usually square-shaped and sprinkled with powdered sugar when served hot.

bisque (bisk): Rich, creamy soup. Crawfish bisque is prepared with stuffed crawfish heads.

boudin (boo-dan): Hot and spicy pork that's ground and mixed with onions, spices, herbs and cooked rice and then stuffed into a sausage casing. A popular sports cheer is "Hot Boudin, Cold Couche-Couche, Come on Bulldogs, Push-Push-Push."

boulettes (boo-lets): Meatballs, whether meat or seafood, mixed with seasonings and breadcrumbs and deep-fried in oil.

bread pudding: Rich dessert prepared using leftover bread (French bread can also be used) that is torn into pieces; soaked in a milk, egg, sugar and vanilla flavoring mixture; and then baked. Rum sauce is often poured over the tasty delight.

café au lait (kah-fay-oh-lay): French for coffee with "steamed" milk.

cayenne: Hot, ground red pepper used liberally to season Cajun dishes.

chaudin (show-dan): Stomach of a pig stuffed with sausage. Also known as gog or ponce.

chaurice (shoe-reese): Fresh, spicy pork sausage, often used in red beans and rice dish.

chow-chow: A peck of pickled peppers make "chow chow," the relish that is a fixture on southern tables, especially in Louisiana, to add some nice spice to dishes. It's good mixed in with scrambled eggs, on hamburgers and hot dogs and as a topping to pizza. Cooks add a spoonful or two to gumbo or roast. It usually starts in the home garden as a way to use up surplus vegetables to preserve them. In some places, it's called "piccalilli."

couche-couche (koosh-koosh): Breakfast dish known as Cajun cereal. Made by frying cornmeal in a black iron skillet on top of the stove and served by topping it with milk and/or cane syrup.

court-bouillon (coo-bee-yon): Spicy stew made with fish fillets, tomatoes, onions and mixed vegetables.

cracklings: Crunchy morsels made from either pork skin or back fat that are fried until crispy—golden brown on the outside and tender inside, like a pork French fry. Also called gratins.

crawfish: As the state crustacean, crawfish is worshiped through numerous Cajun dishes—pies, étouffée, fried or boiled with corn, mushrooms, onions and potatoes. Outside of Cajun Country, it may be called a mudbug or crayfish.

dirty rice: Side dish of rice cooked with green peppers, onions, celery and a variety of spices, pork liver and giblets. Also known as rice dressing.

étouffée (eh-too fay): Meaning "smothered" in French. A method of cooking seafood or meats smothered in vegetables thickened by roux, such as crawfish etouffée.

filé (fee-lay): Finely ground sassafras leaves added at the end of cooking to season and thicken gumbo.

fricassee (free-kay-say): Thick, chunky stew made by browning and then removing meat from the pan, making a roux with the pan drippings and then returning meat to slow-cook in the thick gravy. Chicken fricassee is a popular dish.

gateau de sirop: Syrup cake with no frosting and no sugar.

grillades: Cuts of beef or pork marinated in spices and herbs for grilling, frying or stewing. Grillades and grits is a popular dish for "brunch."

gumbo: Thick soup cooked for hours using seafood or meat, countless spices, vegetables and served over rice. There are many variations—shrimp and okra, duck and andouille, seafood, chicken and sausage gumbo. The word *gumbo* (or *gombo*) is an African word for okra.

hogshead cheese: Cajun pork "pate" that really isn't cheese but rather a "meat jelly."

jambalaya (jam-bah-lie-ya or jum-bah-lie-ya): A one-pot, spicy rice dish. A good place to start in preparing this hearty meal is by checking for leftovers in the fridge. Cooks throw in a variety of andouille, chicken, beef, ham or shrimp along with vegetables and spices. *Ya-ya* is an African word for rice.

king cake: Traditional Mardi Gras cake, similar to a coffee cake but decorated in purple, gold and green representing justice, power and faith, respectively. A small plastic baby is inserted in the king cake, and the individual who gets the baby in his or her slice must buy the next cake.

maque choux (mock-shoo): Smothered corn, tomatoes, onions and peppers. Sometimes shrimp or crawfish are added to make this a main dish.

muffuletta (moo-fa-let-la): Round sandwich, originating in New Orleans with Italian meats and cheeses and a layer of olive salad.

oreilles de cochon (oh-rail de koh shon): Sweet pastry literally meaning "pig's ear" in French because of the shape of the crunchy fritters, dipped in syrup and pecans.

pain perdu (pan-per-doo): French for "lost bread." Simply French toast, served for breakfast. Stale bread is soaked in an egg batter (it's okay to add cinnamon) and then pan fried on both sides. Served with a topping of powdered sugar or spoonful of cane syrup. It's bread that would be "lost" if not prepared this way.

poor boy/po-boy: French bread sandwich originating in New Orleans with meats or seafood and traditionally dressed with lettuce, tomatoes and mayo. Fried shrimp po-boys are popular.

praline (prah-leen): Smooth, creamy candy cooked on the stovetop and made of sugar, milk, butter, vanilla and pecans.

red beans and rice: Main dish prepared with kidney beans, seasonings and spices served over a bed of rice. Usually made with chunks of andouille, sausage or tasso. Traditionally served on Monday's washday as an easy dish that requires little prep work. Just throw in the ingredients and cover the pot to simmer for hours.

roux (roo): This is the beginning of many Cajun dishes such as gumbo and étouffée. It's a combination of flour and cooking oil cooked over heat with lots of stirring involved until it reaches a rich brown color. Cajun roux consists of flour and oil, while Creole roux combines flour and butter.

sauce piquante (sauce pee-kawnt): Spicy stew with tomatoes, cayenne pepper and other seasonings. Popular variations are squirrel, rabbit or turtle sauce piquante.

tarte a la bouie (tart a la boo-yee): Sweet dough custard tarts of eggs and milk. It's an old dessert along the bayous.

tasso (tah-so): Cajun ham made from the pork shoulder, cured in a salt box, heavily spiced and smoked. Popular for adding smoke and spice to gumbo and greens.

trinity: Mixture of diced celery, bell peppers and onions that form the flavor base of many Cajun dishes.

BIBLIOGRAPHY

Barnum, Phineas. *The Life of P.T. Barnum Written by Himself.* Urbana: University of Illinois Press, 2000.

Bernard, Shane K. *Tabasco, an Illustrated History: The Story of the McIlhenny Family of Avery Island, Louisiana.* Avery Island, LA: McIlhenny Company, 2007.

Bienvenu, Marcelle. *Stir the Pot: The History of Cajun Cuisine.* New York: Hippocrene Books, 2005.

Bluysen, Judith. *Cajun: A Culinary Tour of Louisiana.* New York: Rizzoli International Publications Inc., 2002.

Carson, Gerald. *The Old Country Store.* New York: Oxford University Press, 1954.

Cultural Arts Committee, Louisiana Extension Homemakers Council. *Bicentennial Louisiana: Historic Sketches and Regional Recipes from the Parishes.* N.p.: self-published, 1976.

Eakin, Sue. *Washington, Louisiana.* Bossier City, LA: Everett Companies, 1988.

Edge, John T. *Southern Belly: The Ultimate Food Lover's Companion to the South.* Athens, GA: Hill Street Press, 2000.

Escott, Colin. *Hank Williams, the Biography.* Boston: Little, Brown and Company, 1994.

Esman, Marjorie R., PhD. *The Town that Crawfish Built.* Baton Rouge, LA: VAAPR Inc., 1984.

Fontenot, Nicole Denee. *Cooking with Cajun Women.* New York: Hippocrene Books, 2002.

Gauthreaux, Alan G. *Italian Louisiana: History, Heritage and Tradition.* Charleston, SC: The History Press, 2014.

Griffin, Harry Lewis. *The Attakapas Country*. Gretna, LA: Pelican Publishing, 1959.

Gutierrez, C. Paige. *Cajun Foodways*. Jackson: University Press of Mississippi, 1992.

Hand, Edie, and Colonel William G. Paul. *Cajun and Creole Cooking: The Folklore and Art of Louisiana Cooking*. Nashville, TN: Cumberland House Publishing, 2007.

Henry, Judy Clerc. *Louisiana Rose Cousins*. USA: self-published, 2013.

Horst, Jerald, and Glenda Horst. *Louisiana Seafood Bible: Oysters*. Gretna, LA: Pelican Publishing Company, 2011.

Kalman, Bobbie. *The General Store*. New York: Crabtree Publishing Company, 1997.

Leeper, Claire D'Artois. *Louisiana Place Names*. Baton Rouge: Louisiana State University Press, 2012.

Mamalakis, Mario. *If They Could Talk*. Lafayette, LA: Lafayette Centennial Commission, 1983.

Margavio, A.V., and Jerome J. Salomone. *Bread and Respect: the Italians of Louisiana*. Gretna, LA: Pelican Publishing Company, 2002.

McCaffety, Kerri. *Saint Joseph Altars*. Gretna, LA: Pelican Publishing Company, 2013.

Mier, Shelby, and Betty Mier. *The Monniers of Vermilionville (Lafayette)*. Lafayette, LA: self-published, 1992.

Reed, Dale Volberg, John Shelton Reed and John T. Edge. *Cornbread Nation: The Best of Southern Food Writing*. Athens: University of George Press, 2008.

Rees, Grover. *A Narrative History of Breaux Bridge*. St. Martinville, LA: Attakapas Historical Association, 1976.

Stein, R. Conrad. *The Home Front during World War II in American History*. Berkeley Heights, NJ: Enslow Publishers Inc., 2003.

Sternberg, Mary Ann. *Along the River Road: Past and Present on Louisiana's Historic Byway*. Baton Rouge: Louisiana State University Press, 1996.

INDEX

ABOUT THE AUTHOR

Dixie Poché is a graduate of the University of Louisiana–Lafayette in journalism. She is a travel and corporate writer in Lafayette, Louisiana, and has lots of Cajun cousins to hang out with on the front porch.

Visit us at
www.historypress.net
..
This title is also available as an e-book